This book is dedicated to my very talented wife Janice, for her continuous support and encouragement on our creative journey.

"Marc's new book is an all-in-one, easily accessible handbook drawn from his huge library of interviews with top photographers — and packed with information that can be put into action immediately. This book will show you how the pros do it. Study this and take your best shot."

– **Chase Jarvis,** award-winning photographer and founder & CEO of CreativeLive

"I've come to read, review and occasionally edit several books on photography. Thus, I feel particularly proud and honored to present Marc Silber's unique handbook. It's the first of its kind that will grant you that little extra that will make you a better photographer, by introducing you to the essential and paramount creative cycle of photography. Renowned interviewer, Marc Silber's emphatic flow of his narrative will undoubtedly attract any reader, and feed his mojo."

– **Jerome Milac**, photographer & author

"*Advancing Your Photography* is a work of art, about art! Silber delivers clear, concise content, for all levels of skill, and accentuates the details that matter most to getting the result you desire. As an amateur myself, I felt more professionally suited to capture a meaningful photograph by applying what I learned."

– **David Lee Jensen**, #1 bestselling author of *The Naked Interview*

"Marc Silber has great insight into the photographic community. As an exceptional photographer with an easy interview approach, his videos capture the essence of the photographer."

– **Larry Abitbol**, CEO Bay Photo Labs

"I've been involved personally in some of Marc's work and hope to continue supporting him and his vision in the future. Personally as a blogger and social photographer I'm excited about Marc's new book and am looking forward to helping to promote it across my own sphere of influence on the Web."

–**Thomas Hawk**, photographer and blogger

"This book was easy to read and understand. Everything was laid out in the perfect order for a beginner like me, and by the time I was done I really felt that I could take amazing photos, and was inspired to do so. It is also a visually beautiful book, which increased the quality of the whole experience."

– **Catherine Weaver**, author and educator

"When I first went on a photo walk with Marc Silber, professional photographer, I could see he had a knack of explaining how to get better photographs. Information about photography is much needed; Marc's ability to get professional photographers and historical figures to explain how to get better photography is quite impressive."

– **Robert Scoble**, technical evangelist and author

"Marc Silber's Photography interviews are dialogues that open minds of creative photographers and illuminate, only as photography can, the innovative methods and inspired insights of photographic artists and how they think and work. To see yet another San Francisco Art Institute alumnus flourish in the winds of competition is a testament to the legacy of the institution."

—**Jack Fulton,** photography professor emeritus,
San Francisco Art Institute

"BEGIN AT THE BEGINNING, AND GO ON TILL YOU
COME TO THE END: THEN STOP."

— LEWIS CARROLL, ALICE IN WONDERLAND

TABLE OF CONTENTS

FOREWORD

Photography is my life. It happens to be how I make my living, but before I ever became a professional, I knew this was what I wanted to do. I collected books by photographers I admired and subscribed to every photo magazine available; I was a fanatic. However, I never took a class. I learned by going out, taking photographs, and making mistakes. I started in the days of film, with the expense of having to pay for all those mistakes with film and processing and without any instant feedback. In today's digital world, those barriers have gone. This is both a help and a hindrance. No one expects to pick up a musical instrument and immediately make beautiful music. It takes years of practice, but modern cameras are so technically foolproof it's tempting to think that you can pick up a camera and make great photographs from the get-go. It can happen by chance, but to make consistently good photographs, you must practice, practice, practice.

I still believe the only way to learn and improve is to get out there and shoot, but now you have a resource that gives advice from decades of experience from some of the world's best photographers.

Marc Silber has distilled the essential nuggets of information shared by these photographers in his very successful video series, Advancing Your Photography. I've had the pleasure of knowing Marc for several years and can attest to his dedication to helping photographers of all levels find their vision.

His background as a seasoned working photographer gives him the necessary perspective to ensure you only get information that works. It would be difficult to better his advice.

Use this information and apply it when you are out there shooting. The more you shoot, the better you will know your camera and the less you will be concerned with equipment, so that you can concentrate on the image. So get out, shoot a lot, make mistakes and learn from them. And remember, photography is fun!

Bob Holmes
Marin County

PREFACE

"PHOTOGRAPHY IS A LOVE
AFFAIR WITH LIFE."

— BURK UZZLE, DOCUMENTARY PHOTOGRAPHER

My intention with *Advancing Your Photography* (AYP) is to provide you with a single text that will take you though the entire process of becoming an accomplished photographer. I will do this by teaching and involving you in the stages of the cycle of photography so you can climb, step by step, a stairway that continually spirals up, following its major stages.

As it is a handbook, it is a size that you can take with you in your camera bag and refer to often. In that way it will be your guide and coach and there when you need us.

I have had the wonderfully enlightening experience of interviewing scores of photographers over the last eight years, and I will pass along to you some of the gems that they gave me throughout the book. Since these interviews covered many genres of photography, you'll get tips in the areas you most likely want to know about.

My inspiration for writing this book was the many conversations in these interviews; I discovered that there was no definitive resource book that photographers who wanted to advance their skills could go to for help that was simple and easy to use.

As photography is constantly evolving, I will teach you the basics that are not likely to be constantly shifting.

There is plenty of data available about the newest technology; I want to focus on teaching the fundamentals that will carry you forward in a lifetime of pursuing the art and craftsmanship of photography. I may be leaving myself open to criticism for leaving out what some perceive to be key details, but I chose this path so I can provide you with a handbook you can use, not an encyclopedia of photography.

What you will gain as the reader is an easy to follow guide to help you create photographs that you love. After all, at the end of the day, when you're able to accomplish that, then others will no doubt fall in love with them too!

How to read this book

"TELL ME AND I FORGET. TEACH ME AND I REMEMBER.
INVOLVE ME AND I LEARN."

— BENJAMIN FRANKLIN

Be sure to check in on our resource page at AYPClub.com. This is where you'll find links to my recommendations, videos that accompany the book, and other helpful information.

AYP will open its doors to you and you'll receive its full benefit by following several points that I want to stress:

1. Know the words! Just like my mom repeatedly told me, always look up any word you don't understand as soon as you encounter

it; never try to go past one, or you'll end up confused. Use the glossary in the back, or look in a simple photography dictionary (go to AYPClub.com for recommendations.)

2. You can also google "define _____" – but watch out, some of these start simple but soon get more complex. So grab what you need to understand the word and don't dive in the deep end.

3. "Involve me and I learn." The other point I cannot stress enough is to have your camera or equipment or the software being discussed sitting right there in front of you. Touch it and move or touch whatever I'm talking about as though I'm there with you showing you these points, involving you then and there. So if I'm talking about your lens, look at it, notice what I'm saying, and touch the parts mentioned, etc.

4. The next step of our hands-on approach is to do the practical exercises that I give you. Don't sail past these – you've got to put what you and I have gone over into use NOW!

5. I love notebooks (they have long been a staple for artists) and I recommend that you get a plain black and white "composition book" and write "AYP" on the cover. As photography is a visual subject it helps to use your notebook for "visual thinking" to sketch or write down your discoveries, key words you want

to remember, diagrams and drawings of how something works, and flashes of inspiration! You can also use it as a way to log your advancing skills as a photographer, like a diary.

Leave room in your cup

I have told this story at the start of my workshops:

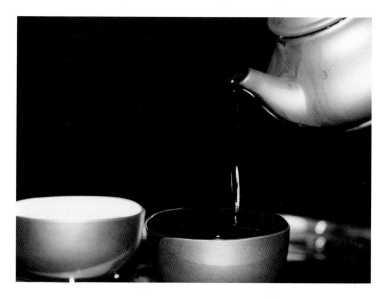

Nan-in, a Japanese master, received a university professor who came to inquire about his teachings.

Nan-in served tea. He poured his visitor's cup full, and then kept on pouring.

The professor watched the overflow until he no longer could restrain himself. "It is overfull. No more will go in!"

"Like this cup," Nan-in said, "you are full of your own opinions and speculations. How can I teach you unless you first empty your cup?"

No matter how much you have studied or your level of skill, be sure to leave room in your cup to learn!

There are two ways to study this book:

1. Start at the beginning and go through it sequentially chapter by chapter, learning as above. I recommend this to you, even if you think you've already studied some of the data. I guarantee you'll learn something new if you leave room in your cup!

2. Or let's say you're on a trip and want to dive into "travel photography" or "wildlife photography" and get some tips to use right away. By all means do so, but I still recommend that you go through chapters 1, 2 and 3 first to have your basics and your camera down cold.

Either way, the important point is to really use AYP and carry it in your camera bag or have it close to hand when processing your photographs, etc. I may even give an award to the most well used copy of it in the field! And show me where and how you're using it by tagging #AYPClub on Instagram (including pages of your notebook).

Sandwich Training

In the UK, college courses are often conducted by "sandwich training" (not in how to make them!) What it means is that study

periods are alternated with practical experience. This is the best way to approach your photography education so as to maintain a good balance. This is why I recommend that when you're studying your camera, you should have it right in front of you. Also break your study time up and go out and shoot. I want you to connect with everything you study in this book.

One last point before we take off: be sure to have fun on your journey! Here are a few tips to help you do so:

1. The sign on my door doesn't say "no shoes – no service," but, "Check self criticism at the door!" It's okay to want to do better, and of course that's the whole point of AYP, but don't be your own worst critic. In other words, allow yourself to win!

2. Study and use the AYP regularly. As when you learn any new skill, you can't dabble at it and expect to get very far. Set your pace weekly and stick to it. I suggest a minimum of one hour, three times a week. Three hours a week isn't a bad investment to make in becoming an accomplished photographer.

3. Take at least one photograph every single day. If you don't have your trusted camera, then use your smartphone. Follow my advice on posting to social media (in Chapter 5), and also tag the ones you are proud of to #AYPClub on Instagram.

4. Don't take it seriously, but have fun. Fall into the joy of learning to express yourself better and more effectively as a photographer.

5. You can always reach out to me with your questions or comments. Reach me on my YouTube channel or on our contact form on AYPClub.com. Unless I get bombarded, I promise to answer every question you send me.

6. Have fun and fall in love with photography more deeply every day!

ACKNOWLEDGMENTS

"I THINK IT IS IN COLLABORATION THAT THE NATURE OF ART IS REVEALED."

— STEVE LACY, JAZZ COMPOSER

In writing this book, I received so much help and support from so many people that it felt like the universe was telling me that my large network of supporters was behind me the whole way. And indeed they were.

I'll begin by thanking Chase Jarvis, for inviting me to his studio for one of our very first videos and for his friendship and continued support throughout the years. Thanks to Bob Holmes for his friendship and for his continued advice and support along the way; he also contributed his time and support in creating our videos that are so loved. Similarly, thanks to Huntington Witherill for his advice and contributions in his videos.

I'd like to thank all those who contributed to our many, many interviews, especially those whose work you see here in AYP: Chris Burkard, Matthew Jordan Smith, Camille Seaman, John Todd, David Smith, Lena Hyde, Anna Kuperberg, Joey L., Hunter Freeman, Florian Schulz and Bambi Cantrell. Without them, the book would lack the dimension that it has.

I'd like to thank those who helped me edit and smooth out AYP: Jerome Milac for his belief in and continued support of AYP; Catherine Weaver for her expert guidance on editing,

Pete Hoffman for his Photoshop mastery and David Jensen for his advice. To my fantastic digital film producers over the years: Rocky Barbanica, Sam Rider, Matt Cross, and Hollie Fleck for their production on our AYP Videos (and thank you, Hollie, for modeling.)

I would especially like to thank my followers who have supported me over the years; without you, I would have had no purpose behind my production, with you, it has meant the world.

And a big thank you to the team at Mango Publishing, especially Chris McKenney, who believed in and supported AYP, and Hugo Villabona, who has been my editor and guide through the project, making this much more fun than a solo expedition and Elina Diaz for her beautiful design.

The Five Stages of Photography

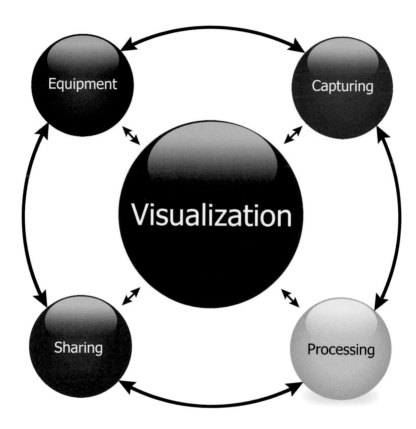

>> Five Stages of photography: Visualization is at the center as it is involved with each of the other stages. Each stage is interactive (with arrows going both ways) since by improving one, you improve the rest. For example: by improving your skills in Processing this will improve your ability to Capture and vice versa. The same is true for each stage of photography.

CHAPTER 1
THE CYCLE OF PHOTOGRAPHY AND ITS PARTS

"PHOTOGRAPHY IS A WAY OF FEELING, OF TOUCHING, OF LOVING. WHAT YOU HAVE CAUGHT ON FILM IS CAPTURED FOREVER..."

– AARON SISKIND, PHOTOGRAPHER

There is a natural cycle to photography, as there is to all parts of life. For example, if you want to learn to cook a certain dish, you follow a natural cycle of first getting an idea of how you want your dish to turn out, consulting the recipe, and getting out your kitchen equipment – pans, cheese grater, etc. (learning how to use each if needed), then cooking the dish, which hopefully comes out how you visualized it, then you share it with others!

I'll be covering each of these parts in detail to help you break down the whole subject into its components to understand them easily.

Now, before I dive into these, I want you to promise me you won't stop taking photographs until you learn all these parts. As I mentioned in the introduction, I want you to take at least one photograph every single day, no matter what camera you use or how you do it. The point of AYP is to advance your photography, and that is done by learning and photographing continuously, okay?

Let's begin with the word "photography" and see how each part of its cycle fits into this definition from the Oxford American Dictionary: "the art or practice of taking and processing photographs." It comes from two Greek words: "phos," meaning "light," plus "graphein," "to write." Put them together and

you have the art of *writing with light!* Just as we write with words to tell stories that communicate ideas, feelings, and emotions, with photography you use light to convey those same ideas and feelings, but depending on your skill, perhaps even more deeply. Remember this derivation as you go through each stage of the cycle of photography: Step by step, you're improving your ability to write with light and thus tell stories with your images.

Now, where does the cycle of photography start? It turns out it doesn't start with the camera, it starts with you!

» **Visualize how you intend to create your photograph**

"LOOK AND THINK BEFORE OPENING THE SHUTTER. THE HEART AND MIND ARE THE TRUE LENS OF THE CAMERA."

— YOUSUF KARSH, PHOTOGRAPHER

That leads us to the first and most important part of the photography cycle: it's what we call **visualization**, or the process of forming a mental image of what you are going to photograph and how you intend it to look as an end result of all the stages of photography, that's why it is in the center of the cycle. After all, to even pick up a camera, you had to first have some idea of what you wanted to capture, no matter how brief or vague. I will teach you how to

develop your powerful sense of visualization, which in itself will make you a better photographer almost instantly!

A big part of visualization is looking at others' work, both photography and other art forms. You get ideas from others about how they were able to tell the story with their camera or paintbrush. But it's not good enough to look at a photograph and say, "I like this, I don't like that." That won't let you into the inner workings of that image. Go deeper: if you like it, look at the image and see why you like it. Did it have an emotional impact on you, and if so, what was it?

If you don't like it, see if you can dig in and find out why. Maybe there was something distracting about it or it had a technical flaw. Or it simply didn't interest you.

This kind of careful looking will help you when you go out to capture your own images. You're building a kind of visual collection in your mind from which to work.

When I was learning photography as a pre-teen and teenager, I looked at a few photographers and their books over and over, and I recommend you do, too. Google them to see their images:

Ansel Adams: He is the master of landscape photography. I ended up studying all of his technical books. Look at his work and see how he was able to capture nature so effectively that you feel you are right there with him.

Henri Cartier-Bresson: He was the master of "capturing the moment" – shooting the events of the day, whether it was a

formal ball or the man on the street. He had the ability to make art out of everyday events and bring us into direct contact with them. Cartier-Bresson used a Leica, a small handheld camera.

By closely studying the work of these two master photographers, you will get some insight into two of the most prolific and popular photographers of the twentieth century, and by looking deeply, you can find out why they became that way. I also invite you to search for photographers you admire and study their work as I've described.

Another book of the time that I looked at often for inspiration is "The Family of Man," which began as an exhibition and later became a book. It is a collection of 503 images by 273 photographers from 68 countries; each image tells its own story, but like pages of a book, they fit together to tell a whole story about mankind.

There were many, many other books and exhibits that inspired me, and I'm sure you have your own favorites too. These will all help you to develop your own "voice" as a photographer. Let's talk about how to use visualization when you go out to take a photograph. Instead of being someone who just pushes the shutter and snaps a lot of pictures (snapshots), a photographer first visualizes the image he or she wants and then goes through the steps to capture it. The moment I really learned to visualize is when I became a photographer, and it has been a lifelong love affair ever since.

The next stage of the cycle is **knowing your camera** and equipment. To bring to life what you have visualized, you have to know your tools and know them well. I will demystify your camera and make it an easy-to-use set of tools that will help you create the images that you love.

You might have felt intimidated when you first picked up a professional camera, it seems like there are just so many knobs, buttons, and menus and things. How could you possibly know them all? The good news is you don't need to!

For over 100 years cameras have had only four or five key controls that you had to know how to work with. The same is mostly true today.

Let's go back to the kitchen and imagine you were learning to cook in a well-equipped kitchen – which made your head spin with all the appliances, cooking utensils, pans – and on and on!

But let's say you decided to watch and follow a good cook at work who made it look easy and simple. You noticed they also used the same key "tools" over and over, no matter how many dishes they cooked: They used knives to cut with, they used pots and pans of different sizes, spatulas and spoons – and hey, they seemed to do all their work with just a few key tools of the same kind! Then it really hit home that it's simple and that you too could learn to cook!

The same is true with photography: once you learn the five or so key controls, you will simply use them over and over again, no matter what type of photograph you're creating. When we get to that section, we'll cover them all so that you know how to use them, then with practice, these will become instinctive for you.

When your visualization is coupled with your ability to use your camera, you will then be able to capture the image that you want, so **capturing** the image is a blend of those two stages, but forms its own stage in the cycle. When you go to the next stage of processing you may find you will change how you develop an image, but you must know how to expose it and capture it correctly in the first place with your camera and your other tools.

As an analogy, if you were recording music, you would need to do so in a way that captures it faithfully and clearly, so when you play it back you hear clear sounds that are harmonious with other instruments and sound pleasing. Have you ever been to a concert where you were so totally captivated with the performance, you shot video of it on your phone and played it back the next day for a friend? I doubt they had the same experience you did – your friend may have smiled weakly and tapped their foot a bit and hoped you turned it off soon!

I'm sure you've had the same experience with a photograph of a sunset. Standing there, you were completely surrounded by a moment so beautiful that you knew you couldn't help but get a killer image of it. You took the photograph, but then looked at it the next day and thought. "Why are the colors so muted? The sunset itself is so insignificant! I'm ready to delete the whole image!" Then maybe you might see a pro's shot of the very same sunset that blows you away!

» Processing your images in Lightroom

The next stage is **processing** those images. This is where you play the music that you captured in the last stage. In our modern world this is mostly done digitally, so we will focus on the use of Adobe LightRoom, which I highly recommend as your processing platform.

Remember, the process of visualization is at the center of and carries through each stage in the cycle of photography: What you first visualized and then captured with your camera now needs to

fully come to life as your final image. This is where you learn to interpret your image and have it express what you saw and felt and what you want your viewer to feel when you share it in the next stage.

When I was 12, my teacher, who happened to be a photographer, asked if I wanted to see how negatives were developed and printed. I jumped at the chance, but really had no idea of the magic I was about to experience. He showed me how to develop a roll of film. That was exciting, but it wasn't until it was dried and he put a strip in the enlarger that I began to realize that this was going to be a passion. I stood by in amazement as I watched him expose the paper with the enlarger and then place the paper in the developing tray. Moving it gently back and forth, with only faint yellow light to see by in the darkroom, I could gradually perceive an image forming on the paper, stronger and stronger as the seconds ticked by. Then there it was, fully formed, so he placed it briefly in the "stop bath" to do just that – stop the development. Then into the fixer bath, so it would remain fixed in the process and not fade in the light. And finally a long rinse in water to wash out all the chemicals, which completed the whole development cycle.

Once I had experienced this magic, I was hooked! It wasn't long before I had convinced my parents to allow me to convert the laundry room/shop to do triple duty as a darkroom. Now the magic was complete because I was fully in control of the process!

When all this came together for me and I compared my new final prints that I had made myself to the washed-out, muddy, tiny prints that the drugstore had previously provided me, I

never looked back. I was now the master of my own ship as a photographer, and it didn't matter if I hit the rocks: I learned from every failure, and my successes as a photographer far outstripped the failures.

When I learned to process my images and turn them into prints, I became a "Photographer" with a capital P!

Although the process is far easier in the digital darkroom (and believe me, I don't miss breathing chemicals and getting them on my skin), the darkroom process is mimicked in the process of creation using Photoshop and LightRoom.

Here's more good news: It's far easier to become skilled at LightRoom than it ever was to work in a darkroom. Also, once you work out the settings for your "development" they remain that way until you change them, making the process so much easier.

"But Marc, what about all those sliders, panels, and menus? How will I ever learn all that?!" Hold on, just as I told you that there are only about five key control points for a camera that you need to master, there are a limited number for processing that you need to understand and be able to control.

The number of these comes to about a dozen or so, but taking it step by step, you'll get there with practice so that you can develop images that you're really happy with, and hopefully love!

Now you're ready for the final stage of **sharing** your photographs. The key point is that it's not enough for you to be in love with your own photographs, you need to share them and show the world what you have created!

The process of visualization guides your sharing as well: when you first had the idea for your image, what did you intend to do with it at the end of the cycle? You might have thought it would make a cool post for Instagram or Facebook, or perhaps during the processing stage you realized it would make a great print for your wall.

Now you're going to decide where and how to share it. It's easy to share to social media using Lightroom. This is made even easier because you can sync the desktop version of the software with your smartphone, which makes it really simple to post your images.

I also want you to make your best images into prints, in keeping with the long heritage of photography. There is something so satisfying about having the photographs you have envisioned printed and in your hands. You'll never have the same feeling from looking at them on a computer screen. Then take the ones you really love and have them framed, or frame them yourself, and hang them well, sharing your work in your environment. It fully completes the cycle of photography when others view your work and experience an emotional impact from it.

Before you get discouraged by now having yet another whole new set of skills to learn to make professional prints, let me tell you we're not going there. I use a lab to make these prints. It's far easier and more cost-effective to send photos to a lab to get high-quality prints without the hassle and expense of setting up your own printing. Some will argue with me on this point, and those who do can certainly go ahead and make their own prints. But for most of us, it simply doesn't make sense. I'll give you some options for working with your lab in a hands-on way when we get to that chapter.

I feel the same way about framing. I used to do it myself, but for many years now I have teamed up with a professional framer to help me carry out this final stage of visualization of my image. We'll talk about these options as well later on.

What if you want to get your work into shows, or into stores? Yes, I'll give you some easy advice on how to get started. You may well find that you want to go professional and make photography your career or a second job. Once you have mastered the above steps, you can go in that direction.

CRASH COURSE/SUMMARY

1. Photography is writing with light to tell a story, following a natural cycle of five stages.

2. It begins with you and your ability to visualize the image that you want to capture, and that process will guide you through all the other steps.

3. Closely study others' work to build a visual collection in your mind.

4. Your next step is to learn the key controls of your camera and other equipment.

5. Once you master these points you will learn to capture the image you love.

6. You'll then be ready to process that image digitally, concentrating on the basics so you can get right to work in your "Digital Darkroom."

7. Finally, you'll learn about how to share your work in many ways.

Think of moving along on these stages as a spiral staircase rather than an elevator that goes one floor at a time. By climbing the staircase, you will find yourself back at the position where you started, but at a higher level each time you climb up. Each step of the cycle of photography operates interactively with the others. For example, you'll find learning to process will help you to improve your visualization skills. Also, by sharing with others,

you'll find out what they see and feel when looking at your images, and of course that helps you refine the whole process to better communicate your vision.

I'm happy to be here to help you with your lifelong journey of learning and improving your skills as a photographer.

CHAPTER 2
VISUALIZATION

"VISUALIZE THIS THING THAT YOU WANT, SEE IT, FEEL IT, BELIEVE IN IT. MAKE YOUR MENTAL BLUEPRINT, AND BEGIN TO BUILD."

— ROBERT COLLIER, AUTHOR.

The first and most important part of the cycle of photography is "visualization." This term dates from 1883 and means "the action or fact of visualizing; the power or process of forming a mental picture or vision of something not actually present to the sight; a picture thus formed." Oxford Dictionary. It comes from a Latin word meaning "sight" and an earlier word meaning "to see." It's another way of saying "using your ability to imagine or get a mental view of something."

Can you remember a time when you visualized a photograph before you pressed the shutter and then took the photograph? This is taking the photograph with definite purpose or intention, rather that just letting it happen and hoping you'll get what you want or just taking snapshots.

With all of the steps of photography, why is visualization the central and most important part in the whole process? Because it guides every single step of the process, without which it would be like trying to build a house without plans, or make a movie with no script, or sail a boat without charts. In all of these activities, you would end up wandering around and never achieving your goals, which would be wasteful and very frustrating.

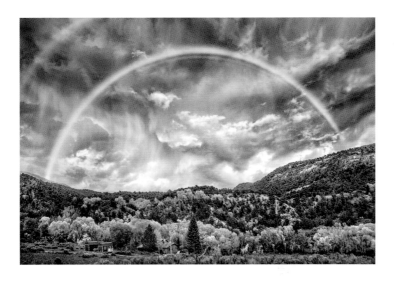

» Rainbow, Near Rifle, CO, Huntington Witherill

Before we look at the last century's masters, let me introduce you to Huntington Witherill, a very creative and eclectic photographer who was named "Artist of the Year." He told me, "What I try to do with visualization is to use my imagination, together with a variety of photographic tools – in order to take what is already out there in the world and to transform it into a composition that will render a given scene as being visually compelling beyond a strict literal translation."

I can't emphasize strongly enough that the fastest way to elevate the quality of your photography is to visualize the final photograph before you press the shutter. But before you go out and start practicing (I bet you're ready), let's take a further look at what some of the masters had to say about visualization in photography.

Alfred Stieglitz (1864–1946) was known as the "father of modern photography" and was one of the most respected photographers of his day. He emphasized that his process was to see in his "mind's eye" the photograph that he intended to create, in order to convey what he "saw and felt" at that moment. He said, "I have a vision of life, and I try to find equivalents for it in the form of photographs."

Equivalent here means "something that is considered to be equal to or have the same effect, value, or meaning as something else." It comes from a Latin word meaning "be strong." (Encarta College Dictionary) Thus, when you convey the equivalent of what you saw and felt, it can be very strong for the viewer. Having a "vision of life" of what you see and feel when you view a particular scene is what sparks the whole creative process. You are conveying a message including emotions to your viewers that they can connect with.

Another milestone photographer was Minor White (1908–1976), who taught the steps of visualization. Here's what he said:

"Previsualization refers to the learnable power to look at a scene, person, place or situation and 'see' at the same time on the back of the eyelids, or 'sense' deep in the mind or body, the various ways photography can render the subject. Then out of all the potential renderings select one to photograph. Such selection makes up a large share of the photographer's creativity."

I agree, but I prefer the term visualization to "previsualization" as I want to emphasize that visualization carries through the

entire cycle of photography, not just "pre-" or at the beginning. I also believe that the process occurs mentally and spiritually, not within the body.

The common point from these artists is that you as the photographer have a huge choice of tools to use for how to capture a photograph and how you render it from there. Think about just a few of your choices: Do you use your smartphone or DSLR? Do you intend it to be black and white, or color? Will you post it on social media or do you hope to eventually print and frame it? Then there are all the settings available to you to get the desired result you want. Later I'll cover some examples of my images and tell you my story of visualization.

Minor White also said, "One should not only photograph things for what they are but for what else they are."

That is another part of the visualization process: Look for what you see, but look more deeply for what else is in the image.

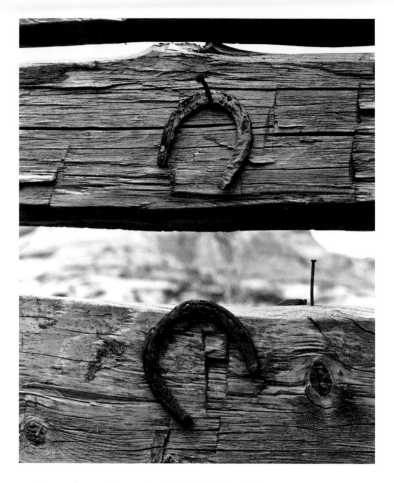

» Horseshoes, Canyonlands, Utah, Marc Silber

Some of the best examples of photographing "what else they are"
are by Edward Weston (1886–1958), a contemporary of Minor
White. Look at his images to see how he was able to photograph
everyday objects to show what else they were, revealing the
beauty all around us. As a note about Weston, he used a very
simple printing process, so all of his attention was really centered
on visualization and capturing the image.

He said this about his process: "Anything that excites me for any reason, I will photograph; not searching for unusual subject matter, but making the commonplace unusual."

Again, I don't want to lead you to believe that only the past masters talked about visualization. In my hundreds of interviews with leading photographers, most of them discussed it in some way as part of their process. As an example, Chase Jarvis, an award winning photographer and Founder & CEO of CreativeLive, told me about his process:

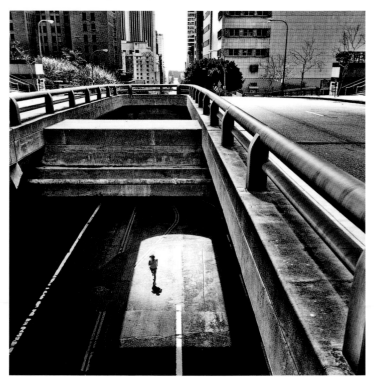

» Runner, Chase Jarvis

"The first thing I do is walk around and look at the scene without a camera, because when you put the camera to your face, you see a lot less than you do just walking around. So I walk the area I'm going to shoot and look for interesting things. When I find things I'm going to shoot or that I can build into a scene in my mind, I'll start putting the pieces together, and that's kind of a visualization for me. So when I'm visualizing I know exactly how I want this thing to look – I even pre-visualize what this could look like in post-production. Then I fantasize about it a little bit and think, 'What could I put in here to make it the absolute best picture it can be?'"

MAKE A SHOOT PLAN AND SHOT LIST

Note: I use "capture", "image" and "shot" interchangeably to mean a photograph. I use "shoot" or "capture" as the verb; the action of photographing. I'm not a snob about always saying "capture" or "image" (example: "nice capture" or "great image"). I use "shot" to mean "an image captured deliberately," as opposed to "snapshot" – one taken quickly as a toss-off.

The action of visualization also extends to your planning before you even arrive on the scene you're going to shoot. I do this all the time when I'm traveling. For example, when I went to Paris, there were certain images that I knew I wanted to come back with. One was the Eiffel Tower, but it had to be a unique shot, not one that looked like a cliché or postcard – that was as far as I'd visualized it before I arrived there. And by the way, that is the trick to capture an image that has been photographed a million times: Find some new angle or a new way to approach it that is your own way of looking at it. When I was at the tower, I tried various angles and ways of looking at it until I captured this image:

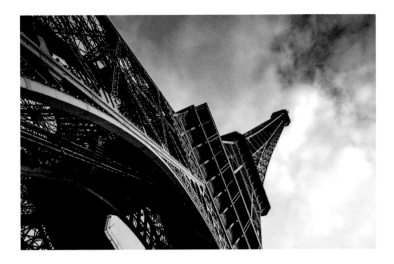

>> **Eiffel Tower, Paris, Marc Silber**

I recommend that you make a shot list before you go on your next vacation. Do some research ahead of time to see what's already been photographed, and to get some ideas for when and where you might shoot. That in itself can add a whole new level to your travel, guiding your entire trip with new purpose.

When you are shooting an event, particularly a wedding, there are certain mandatory shots that you must get, so you don't leave out the bride's favorite aunt or niece for example. But on the other hand, you want to capture those spontaneous moments that no one could have anticipated, which we'll talk more about later. The answer then is to write a detailed shot list and get each and every shot on it, and *then* get your spontaneous shots.

A shoot plan where you plan and sketch out what you intend to shoot is also helpful, when this makes sense. Your drawing can

be simple and not necessarily artistic, as it is just a guide. When you get to the scene, you'll already have some ideas for where and how you'll get the shots you want. It's useful when you have a tight schedule to follow, such as an event or performance. This will also cause you to think through all the details so you can create the photographs that you intend.

For example, your son or daughter is graduating from high school or college (or you are), and you want to come away with some really memorable images. There's little chance that you'll get those memorable shots from way back at the venue. Thinking like a photographer, you plan how to get up close and get a really great image. This is one of the advantages of being a photographer: it can afford you great access, right past the normal barriers!

Your shoot plan then drives all the other items that must be in place to capture that great image: the equipment you'll need (maybe a tripod, telephoto lens, etc.), the location you'll want to arrange access to ahead of time (as above), and the timing of the shoot itself. This planning all comes under the heading of visualization.

HOW ABOUT BEING SPONTANEOUS AND "CAPTURING THE MOMENT?"

That is a very good question and shows that you're paying attention and thinking about what I'm going over with you.

The best answer is from a photographer I introduced you to in the last chapter: Henri Cartier-Bresson.

Cartier-Bresson captured what he called the "Decisive Moment", where he photographed his subject at exactly the moment that captured the true spirit of their action. In order to hit the exact right moment, he had to be prepared for the precise instant to press the shutter. If he waited until he saw it, chances are that because of the lag of his finger pressing the button and the lag of the camera itself, by then that moment could have passed. So by being aware of the action and being prepared, he was able to judge the exact moment to press the shutter an instant before that decisive moment occurred.

Nancy Newhall, a biographer of photographers, described his process: "...you photographed the developing action until the climax was reached and you achieved ONE picture out of the whole roll, or even several rolls, which summarized the whole. For this kind of picturemaking you must be forever alert. The action happens just once in all time. There is no retake ever. No prearrangement, no direction will ever bring the same unmistakable flash of insight into actuality."

A great example of Cartier-Bresson's "Decisive Moment" is his image of a man jumping over a puddle (Google it). By being prepared for the action, he was able to capture the man a split second before his right foot hit the water. When he saw this man about to make the leap, Henri must have visualized the image in a split second and immediately readied himself to capture it – which is all part of visualization, but greatly sped up to match the pace of the action taking place.

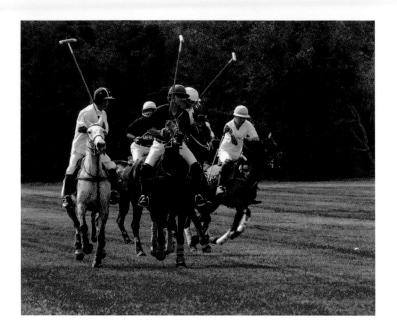

» Polo, Atherton, CA, Marc Silber

I have an example that combines many of these elements in the
photograph above. I was on assignment from Gentry Magazine
to capture, as they put it, "some exquisite images of a place you
thought you already knew." I visualized various images that
I wanted to capture and that I believed it would surprise people to
learn were right in their backyard, a suburban area of Silicon Valley.

I knew I wanted to capture the polo field in action as part of my
shot list. I situated myself, anticipating where the action on the
field was going to occur. I wanted to shoot a tight image of the
players together at the decisive moment, not when they were
scattered around the field. The moment was there; by visualizing
it, anticipating the action, and pressing the shutter at the exact

right moment, I was able to capture the players in a tight group, with their mallets forming an arc. A moment later they were scatted again.

Here's another example of visualizing the final image and anticipating the action of my friends jumping off a sand dune in Morro Bay, on the California coast. The sun was behind them so they were perfectly silhouetted. I took a few frames from the side, but that wasn't particularly interesting. (you can see these on page 121) Then I had the idea of getting below them on the sand dune and capturing them in mid-air, so I moved into position and told them to jump (like calling "Action!" as a director). I anticipated it correctly and was able to capture them in an arc, which again a split second later fell apart.

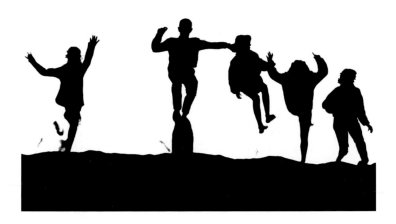

>> **Friends Jumping, Morro Bay, CA, Marc Silber**

What about just getting the shot? Aren't there times when you're out for a walk to the store to pick up beer and pizza, and you see

a shot and take it, completely unprepared? Yes, of course, and you should be ready for such and have your camera (even if only a smartphone) ready at all times. Just remember this phrase from Louis Pasteur: "**Chance favors only the prepared mind**." The moral here is that the better prepared you are, the more likely you are to capture that moment.

STRENGTHENING YOUR VISUALIZATION "MUSCLES"

I didn't say "learn how to visualize," because you already know how to do it. As it turns out, the ability to visualize is "standard equipment" from our earliest age. In fact, as kids it might have been at its strongest, and alas, as we grow older we often hear excuses for not being able to imagine and create as we once did. But the visualization ability of the mind is powerful! It just may need some regular exercise to get back in shape.

Can you remember the wonder you had as a child and the flexibility your imagination had? It's that ability we want to focus on at this stage of photography. And by the way, as I told you earlier, I first became a photographer at age 12, and a year later made the jumping picture above. I am so grateful that photography has been the part of my life that has kept me young by causing me to continue to imagine.

FEED YOUR CREATIVITY: GO TO MUSEUMS

In the last chapter, I told you about some of the photographers who have inspired me and recommended looking at others' work. Let's go a bit deeper to find out why and how.

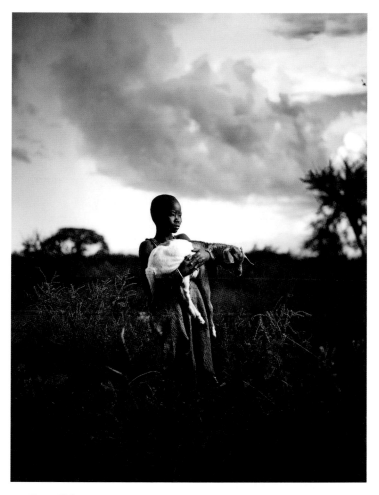

» **Goat Skin, Joey L.**

Some years ago I interviewed a young photographer named
Joey L. He got his start when he was 16 on the first of the *Twilight*
films, and his career just took off from there. Have a look at the
photograph above and his other work, and especially notice his
lighting and composition. He told me he tries to place subjects in

the frame similarly to the way that some of the master painters would. These same masters have also influenced the way he lights his subjects and images as a whole.

Here's Some *Damn Good Advice* from the book of the same title by George Lois, who has been an inspiration for me. While he is not a photographer, he is one of the most creative people I know; in fact, he has said, "Creativity can solve almost any problem – the creative act, the defeat of habit by originality, overcomes everything." Among his many accomplishments, he has designed 92 covers for Esquire magazine, so listen closely to his advice about feeding your creativity:

"You must continuously feed the inner beast that sparks and inspires. I contend that the DNA of talent is stored within the great museums of the world."

"Mysteriously, the history of the art of mankind can inspire breakthrough conceptual thinking in any field."

Take George's advice and spend plenty of time looking at art (he does it weekly on Sundays). But when you look, don't just glance and say, "That's great. That's strange," etc. Really look deeply.

Here's the process I suggest; bring your AYP notebook with you to take notes or sketch as you look. If you can't go to a museum, you can do this with books, but don't do it on your computer – you should get as close to the original art as possible:

Select a genre of art that is similar to what you want to photograph. Joey L. does a lot of portraiture, so he was

particularly inspired by the classical painters of the 17th and 18th centuries, but choose your own.

Find a work of art that you are particularly drawn to. Look closely and observe:

A. How was the subject (or subjects) composed within the frame?

B. How were they lit? Where was the light coming from?

C. How did the light strike the subject?

D. Look at each layer: the foreground, middle and background, plus any other layers.

E. What was your eye drawn to?

F. What was de-emphasized by being put in the background or made darker, etc?

G. How did the artist use color?

H. Can you find a pure white and a pure black (representing the full range of black and white)?

I. What is in focus and what is out of focus?

J. What is the overall message or communication?

K. What is its emotional impact? How did it hit you?

Keep up this exercise, taking notes as you go.

Now that you've "fed the inner beast," you're ready for the next step:

TRAIN YOUR EYE TO SEE IMAGES

It's good practice to always look for images, with or without a camera. Whenever you have a moment, riding on a subway, waiting for a meeting, or out on a walk, try to find the images in that environment.

It can help to "frame" with your hands making two "Ls" on top of each other or touching your thumbs together (as you see me doing on page 36), and look through them with only one eye, to simulate what a camera would see with a single lens. Simply find images that are interesting to you. Why not use a camera to do this? Because we're working on training your eye, freed from the camera or any equipment, just you and the scene. Think of it as a workout for your eye!

I often will walk into an environment and just know there is an image there, and like a game of hide and seek, will look for it until I find it!

Repeat the above drills – building your mental collection of art, and then framing with your hands. And feel free to come back with your camera and create an actual image!

CRASH COURSE/SUMMARY

1. The most important and central part of the cycle of photography is visualization: first seeing the photograph as a mental image. It guides all the other parts of the cycle.

2. Train yourself to visualize by carefully examining art and noting key elements.

3. Then go out regularly and look for images, using your hands to create a frame.

4. When you begin to shoot, look over the scene without having the camera pressed to your face, take in the whole area and see what's there.

5. Observe closely what interests or excites you emotionally, spiritually, aesthetically.

6. Look for what you see – what things are, but also what else they are.

7. Visualize the final image and decide how you want to capture it.

8. When shooting action, prepare for the motion and where action is likely to end up happening, and learn to capture the "Decisive Moment."

9. When you see a shot, take it; be prepared and chance will favor you!

10. Your goal with each image is to pass along to the viewer "what you saw and felt."

» *Big Sur CA, Marc Silber*

CHAPTER 3

GET TO KNOW YOUR CAMERA AS A CLOSE FRIEND!

"FOR ME, THE CAMERA IS A SKETCH BOOK, AN INSTRUMENT OF INTUITION AND SPONTANEITY." — HENRI CARTIER-BRESSON

It is now time to not only get to know your camera but to make friends with it; after all, it is your tool to create your art.

Bob Holmes, the multi-award-winning travel photographer, told me, "You should learn your camera inside out, so that it becomes intuitive. You pick it up; you don't even have to think about the settings. And you just respond to what is in front of you."

That is your goal, you want to know the camera so well that you can put all of your attention on capturing what you have visualized, and not be distracted or slowed down by the camera.

In order to arrive at this goal, it is only necessary that you:

- Understand each of the key controls of the camera that we will be going over; be sure to look up any words you encounter that you don't know.

- Make sure in all of your study that your camera is right there in front of you, so you can touch the knobs, menus, controls, etc.

- Practice, practice, practice your settings.

- Get out and shoot, shoot, shoot.

- Repeat the above sequence any time you have trouble understanding or applying something.

I am going to go over the key components of a digital camera with manual controls, just the key ones that you will need to know thoroughly. Later you should study them more deeply on your own, but these are the functions that have been with us for decades and aren't likely to change.

I am going to define them so that you can understand them well enough to use them, not give a full scientific explanation. If you have an appetite for deeper understanding later, by all means dive deeper, but for now let's cover the basics.

The word 'camera' means "a device for recording visual images in the form of photographs..." it comes from the Greek word kamara, "an object with an arched cover." (Oxford American Dictionary) The history of a kamara (camera) goes back to Ancient Greece, when Aristotle discovered that a small hole in a dark room produced an image on the wall opposite to the hole! It wasn't until 1839 that this phenomenon was incorporated into what we call a "camera" in photography.

When you visualized your image, it was in the form of a mental image; now, to actualize and record the visual image, you use a camera.

The camera model you choose makes little difference at this point, except that you need to be able to operate it manually not just on auto. To record what you visualize, you need to be in full control of the camera.

All cameras have a body which has controls for all the settings and to which the lens is attached.

A camera lens is made up of a group of individual lenses that work together to gather and focus light rays, so that you can control the image that you want to record. The word lens comes from Latin "lentil" because its shape was similar to one (see illustration above).

Remember, you are writing with light to create a photograph, and your lens is your tool for doing so, just as a brush is the main tool for a painter.

A lens has several control points:

1. **Focus:** This allows you to focus on the part of your subject that you want your viewer to see clearly. In the last chapter, you looked at how other artists would emphasize or de-emphasize parts of their work by using focus and light.

2. **Focal length** of the lens: This is basically the distance (usually measured in millimeters, or "mm") from the the rear principal point of the lens to the focal point where the image is in focus at the sensor. In a zoom lens this will lengthen (longer focal length = zoomed in or more telephoto) or contract (shorter focal length = zoomed out or wider angle.) If you have a zoom lens, turn the zoom dial now and you'll see this happening and note the focal length numbers as you do this. Do you see how that works?

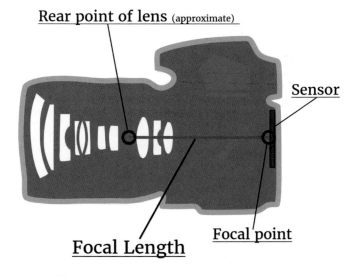

Rear point of lens (approximate)

Sensor

Focal point

Focal Length

Your focal length will tell you how wide or narrow your view through the lens will be, also depending on the size of your sensor.

So let's say you have a "full frame" sensor, which means that it's the same size as a piece of 35mm film, then a "normal" focal length (more or less what you see with your eyes) would be 50mm, a wide lens would be anything less than that, which could

be 35mm or less, and a telephoto lens would be anything longer than 50mm, such as 105mm or 200mm.

To keep it easy, with a zoom lens if you're at 50mm, it's about normal, if you go to 28mm you're wide, and at 105mm you're zooming in.

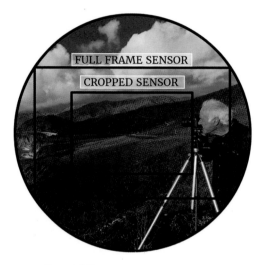

» *Full frame vs. Cropped Sensor*

Now one other thing though is that you might have a camera that has a smaller (or cropped) sensor, which will then magnify your focal length depending upon how much smaller than full frame it is. This is called "focal length multiplier", and commonly this will magnify your focal length by 1.5. So to get a "normal" view, you would set a zoom at about 33mm, and anything less will be wider; anything more is more telephoto or zoomed in. The "focal length multiplier" tells you the amount you would multiply your focal length by for your camera.

Before we go on, find out the sensor size for your camera; it will be in your manual. Or you can google "(camera name and model) crop factor". You'll usually get 1, 1.3, 1.5, or 1.6, from which you can now figure out your actual focal lengths for your camera : multiply this factor by the focal length of your lens. If you have a crop factor of 1.5 and have a 24-70mm lens, its actual focal lengths will be 36-105mm. In the photo above, a full frame sensor would be 50mm, and a 1.5 cropped sensor would be 75mm.

One last point which I briefly mentioned above: You can use a zoom lens, with variable focal lengths such as 28mm-105mm. Or you can use fixed (or "prime") lenses such as a 35mm, 50mm, 105mm, etc. It's up to you. The quality of zoom lenses has increased to where it has become very hard to distinguish the results from what you get using prime lenses, so I use zoom lenses so that I don't need to lug around so many different lenses.

Aperture

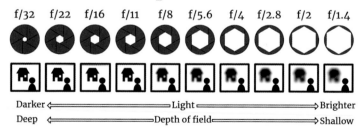

3. "Aperture" simply means an opening or hole and comes from the Latin word "to open." There is an adjustable opening in a lens that changes size called the "iris," similar to those in your eyes. When you go out in bright light, your iris adjusts to become

smaller, thus letting in less light. When you're in a dark area, your iris opens to let in more light. The size of the opening of your camera lens is called the "aperture." The aperture numbers above tell you the size of the opening in each case.

You might ask, "How come as the numbers get larger the opening is narrower?" Actually it's very simple: These are fractions, so when you have a larger number in the bottom of the fraction you get a narrower opening. The fraction is expressed by "f", which stands for the focal length divided by (/) the size of the opening in each case.

You will also hear these openings referred to as "f-stops." *

*Why is it called "f-stop"? They were originally pieces of metal inserted into a lens, one at time, with different sizes of openings called "stops" Lenses have standard "f-stops."

Most photographers keep it simple and say "2.8, 5.6, or f/8, f/16", etc., when stating the aperture or f-stop. When describing their lens as "2.8", it means that lens has a widest opening of 2.8. It's easiest to just think with the numbers and visualize the size of each opening using the preceding chart.

Take a moment to look at your lens. See what its widest opening is, then note the various apertures for your camera. Then using your AYP notebook, sketch out focal length and f-stop until this all clicks into place.

Why is it important to know how to set your aperture? The wider the opening, which means the bigger the value of the fraction or of your f-stop, the more light is let into the lens.

An opening of f/2 is wider than f/3.5, so it lets in more light. But that's not all that changes when you change your aperture, as you can see from the illustration above.

A key element that you want to be fully in control of with your lens is what part of the picture is in focus, and what is not. If you take a portrait of a person or animal standing in Yosemite Valley and it's all in focus, your viewer isn't sure what you want them to look at – the dramatic backdrop of the iconic Half Dome, or the deer that posed for you as it did for me below.

You'll notice the image in Yosemite of the deer is nicely in focus while Half Dome in the background is not, so your eyes naturally go to her. My aperture was set at f/6.3, giving it a fairly narrow focus range.

The way this works is the wider the opening (and so the larger the fraction), the shallower the "depth of field" will be, which really means "depth of focus" or how much is in focus or not. (Refer to chart above.)

But if I set the aperture at 22, then the trees in the background might be in focus and Half Dome would be less blurry.

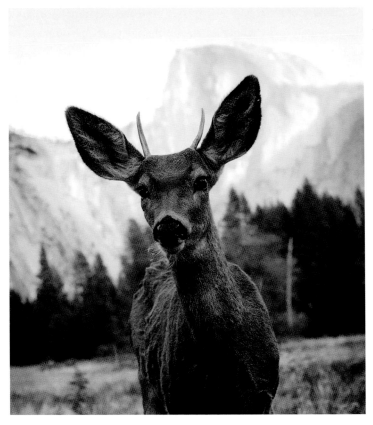

» **Deer calf, Yosemite National Park, CA, Marc Silber**

Let's say you want as much depth of field as possible, like this next image, where I'm again photographing Half Dome in Yosemite and want the viewer to see as much as possible in focus, which with this lens was f/22.

I'm going over these with you as examples of how to control the depth of field, but they are not rules you must follow, they are tools you have at your disposal to render the photograph as

you visualized it. Maybe in the above photo I wanted to have the viewer clearly see Half Dome, and in the one below I only want Half Dome in focus and the rest not in focus. Photography is art, and thus it's your call as the artist as to how you want to create the photograph!

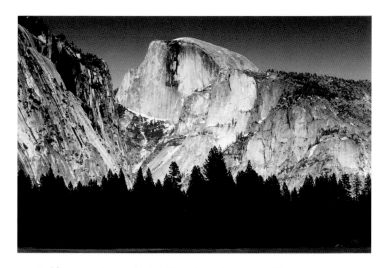

» **Half Dome, Yosemite National Park, Marc Silber**

At this point I'm going to pause to give you a chance to take some example photos so you can see the change in depth of field. Set your camera on Aperture Priority "A" and try shooting the same photo with the widest opening, like perhaps f/2, and the narrowest opening, maybe f/22. Now look at these on your computer and see the difference.

FOCAL LENGTH
& angle of view guide

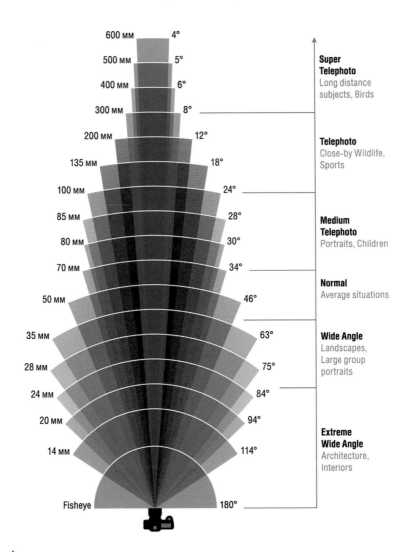

600 мм	4°
500 мм	5°
400 мм	6°
300 мм	8°
200 мм	12°
135 мм	18°
100 мм	24°
85 мм	28°
80 мм	30°
70 мм	34°
50 мм	46°
35 мм	63°
28 мм	75°
24 мм	84°
20 мм	94°
14 мм	114°
Fisheye	180°

Super Telephoto
Long distance subjects, Birds

Telephoto
Close-by Wildlife, Sports

Medium Telephoto
Portraits, Children

Normal
Average situations

Wide Angle
Landscapes, Large group portraits

Extreme Wide Angle
Architecture, Interiors

4. Going back to focal length, if you have a zoom lens, you can zoom in and out and change the focal lengths. Refer to the chart above to see what view you would have with different focal lengths. This also allows you to change what you are having your viewer look at, and this will be determined by how you visualized the image.

5. The only other control you might have on your lens is MF for manual focus or AF for auto focus. For now, I want you to get used to MF so you are in control, not the camera.

6. Most cameras will have a focus magnification button or function to enlarge what you are focusing on by 5x or 10x. This is very helpful, especially with shallow depth of field, such as 2.8. As a note, when you are taking portraits of people or animals, always focus on the eyes: they are the strongest point for your viewer to connect with your subject. For example, the rest of the face can be slightly out of focus, but as long as the eyes are sharp, your viewer will connect, but not the other way around. (Think about how powerful eye contact is in terms of connecting or not with people.)

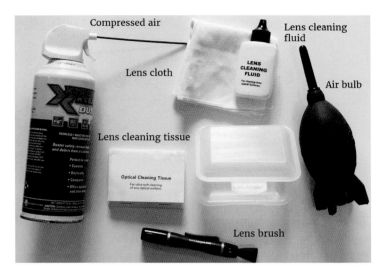

Compressed air — Lens cleaning fluid — Lens cloth — LENS CLEANING FLUID For cleaning lens optical surfaces. — Air bulb — Lens cleaning tissue — Optical Cleaning Tissue For ultra-soft cleaning of any optical surface. — Lens brush

» Lens cleaning kit

Remember to keep your lens clean! Dust or fingerprints are going to mess with the vision you have for your image! Get a good lens cleaning kit and follow this procedure: First use compressed air or an air bulb to blow off any dust on the lens or the ring around it; if you use a cloth with dust still on the lens, you can scratch it, so clean it with air first. If there is still dust sticking to the lens, use a camel hair brush to dust it off, but don't touch the brush with your fingers or you'll get oil on it, which will make dust stick to it. Now take the lens cleaning tissue or cloth that came in your kit, put a drop of lens cleaning fluid on it, and follow the directions on the bottle.

As a note here, be careful when you change your lenses outside—it's best to do so in a car or other enclosed space where dust won't get in. The same is true for changing your memory cards, so you don't get dust in the slot on in the camera.

A CAMERA HAS THESE KEY CONTROL POINTS:

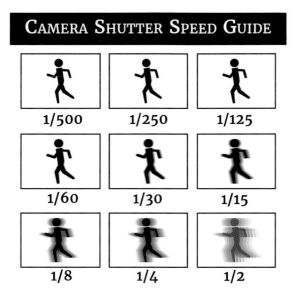

1. The first is your shutter speed. The shutter opens and closes to control the amount of light for exposure, like how shutters work on the windows of your house. The longer it is open, the more light is let in. Shutter speeds can go from relatively very long times, such as seconds or minutes, to very fast, such as 1/100th or 1/500th of a second. You set your shutter speed along with your aperture to get a proper or desired exposure.

Shutter speed also controls whether you stop action or let it blur, giving you another tool to use to tell your story (see chart above of exposures in fractions of seconds.) If your subject is in motion and you want to completely stop the action, use a very fast shutter speed. But let's say you want to show the action and

motion; you might choose a slow shutter speed. The only thing to keep in mind is to avoid camera shake, which will give you unwanted blur. It's best to use a tripod whenever you are using slower shutter speeds (which are exaggerated with a telephoto lens, so if you want sharp images while using telephoto, carry a tripod just in case).

I took the photograph below in the Tuileries Garden in Paris. As soon as I saw the carousel, I knew it would be much more interesting to capture its motion with a long exposure, so I shot it at 1/36th of a second; this is known as "dragging the shutter." The only problem was I didn't follow the advice I just gave you and had no tripod! Never fear, by propping my camera on a metal pole I was able to stabilize it so that the rest of the image is relatively still.

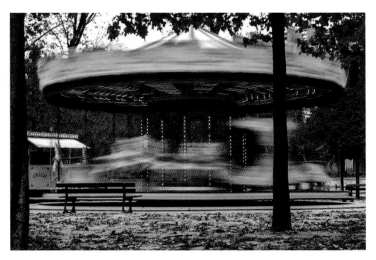

» **Carousel, Tuileries Garden, Paris, Marc Silber**

If you look at the polo match we talked about on page 48,
I wanted to stop the action and so shot it at 1/320th of a second.

2. In your camera, there is a reflective surface, back behind
where the lens attaches, which is called the "sensor." Together
with other digital components, it detects and translates light
into digital information. In film cameras, this is done with
light-sensitive film that is then chemically transformed into a
negative. Both have the same purpose: to capture the light that
came from your lens and was monitored by the points of control
gone over earlier in this chapter.

There is nothing for you to do to operate your sensor, but refer to
your manual to keep it clean.

3. The next control point for exposure is your ISO, which stands
for "International Standardization Organization." That doesn't
say much, it could be standard beds or beer or dog biscuits, but
in our case it means how sensitive your sensor and camera are
to light. ISO usually starts at 100 and can go into the tens of
thousands, or higher as the technology keeps advancing.

What you need to remember is the higher the ISO, the more
sensitive to light it is. But there is a catch, depending on your
camera, at a certain point your image will develop "noise", which
is never pleasing. With film we have grain with higher ISOs, but
this can have a certain aesthetic quality to it. Not so with noise;
just like what happens to sound when you pump up the jam and
turn up your stereo too high, you get unpleasant distortion.

I always use the lowest ISO possible, given the choice; this is good practice to get cleaner images.

4. Choice of settings: There are so many settings and menus that it can look really confusing, but believe me, what we have just gone over are the key points that you're going to set 99% of the time. As we discussed, in a kitchen there are only so many basic tools that you use over and over. The sizes may vary, as with knives, bowls, spoons, etc., but the functions they serve are almost always the same.

Let's cover a few more items and settings you'll need to know:

Memory card: This records the images sent to it by your camera. Use name-brand cards, and take care not to get dust or water in them.

Image types: You're going to have various choices for the type of image you want your camera to record onto your memory card. But while I want you to shoot RAW, I didn't say shoot naked! (I actually had a woman in at a workshop in the Midwest think I said that when she heard me say "shoot raw!"

RAW means what it sounds like, your camera captures the information and sends it to your card unprocessed, like raw uncooked vegetables with all the nutrients intact! We don't want the camera to decide how your image should look: that's your job, and you'll be able to make those choices when we get to the processing stage of the cycle of photography.

If you have a choice, select sRAW "s" for "small" RAW files, which will give you more images per memory card and save space on your computer. Later you can adjust the size upwards.

White Balance: This is a setting that makes it so that the colors your camera sees are what you see, without any unwanted tints or casts. Since you're shooting in raw, you can adjust this later. Just leave it on Auto or AWB.

Putting it all together:

Get to know all the controls I've gone over. The best thing to do is to shoot, shoot, shoot and practice, practice, practice until these all become comfortable for you. Look at your results on a computer so you can really see your focus, depth of field, shutter speed, etc.

Remember, you are creating photographs by writing with light! And remember what Pasteur said: "Chance favors the prepared mind." The better prepared you are, the better results you are able to achieve.

Now let's look at how these controls work together:

Here are my recommended settings (this is how I shoot 90% of the time):

Set on Aperture Priority, this will adjust the shutter speed to your selected aperture. In other words, you set the aperture, and the camera will select the shutter speed it "thinks" is correct for a proper exposure (in a moment, we'll discuss what to do if it doesn't select the correct exposure.) Now adjust your ISO so that

your shutter speed will be adequate. If you're not shooting action, you can go to 125th second. If you are shooting action, you can increase as needed up to 1/350th or 1/500th unless you want to "drag the shutter" as I previously noted.

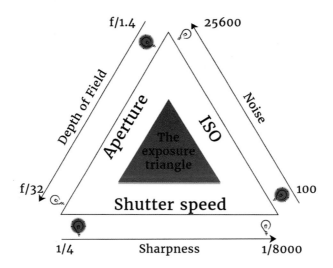

You'll see that you adjust these three to work together to make the exposure you visualized: Aperture → Shutter speed → ISO. Again, the best way to learn is by doing, making your adjustments and looking at the results on your computer.

After you make your exposure, you'll want to look at it in the display on the back of your camera. A handy tool to make sure you haven't overexposed your image (called "clipping") is to enable the "highlight alert" or "highlights." To do so, consult your manual; this will be in one of the menus (often the playback menu.) When this is enabled, if any areas are clipped, they will blink. If it is important information, you can adjust this with "exposure compensation" (again, check your manual) by moving it to the

left by one number or less and taking a new image to see if that handles the blinking; if not then adjust again. Only go far enough to the left to handle the clipping. If you go too far, you'll lose shadow detail.

Hand held photography. Now let's talk about how to hold your camera so that you get a steady shot. You are using your body as your support for your camera, so you want to make it as stable as possible. Find a comfortable and relaxed position so that you're not straining while holding the camera, which can cause camera shake.

How you hold the camera itself is a matter of personal preference. I find that I use my left hand as my primary support, cradling the lens with my left hand and bracing my arms against my body. You can easily see that if your arms are outstretched, you have less support than if they are tucked against your body. Put one foot forward to make a more stable base. Place the camera against your forehead and lean slightly forward, but stay comfortable.

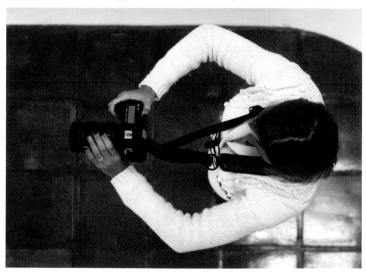

» **Incorrect: arms outstretched, feet together**

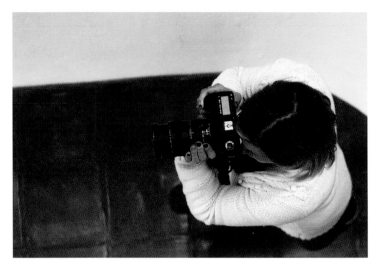

» **Better: elbows tucked in as much as possible, camera against forehead, one foot forward, leaning forward slightly**

Hold the camera in a firm yet relaxed way, so you don't cause it to shake. I control zoom and focus with my left hand, and shutter, aperture, and other controls with my right.

Practice until you have a comfortable position that gives good support for your camera, and allows you to operate your controls easily.

Tripods: I use tripods for three reasons:

1. To provide needed support for slower shutter speeds. Depending on the focal length of your lens, this could be anything less than 1/50th. But when using a telephoto, the camera shake will be exaggerated, so you may need a tripod even at higher shutter speeds.

2. To enable me to keep the position uniform when I want to take the same exact shot more than once. The same holds true for shooting video, if I want a stable camera shot for an interview, for example.

3. To cause me to slow down and fully take in the subject I have visualized, by providing a sort of Zen-like (meaning *really* looking) approach to my photography.

On that point, I'll digress for a moment. As I've said, I learned photography with film where you had 12 or 24 or 36 exposures to a roll. But then I had to develop the film and finally make prints. So like all film photographers, I learned to be selective about when I pressed the shutter. I might return from shooting to find I had several good images on a roll of film. Even though I can pack in tons of shots with a digital camera, I still tend to shoot like I'm using film – a bit more liberally, but with that same mindset. I invite you to do the same.

I suggest that you add a tripod to your toolkit, and learn to use it and experiment with it, as most of them have various ways you can adjust them.

What if you don't have a tripod and need to use a slower shutter speed? I gave the example of being in Paris and using a post in the park. I simply put the camera on top of it, which kept the camera from moving up and down, and then I steadied it with a comfortable/relaxed grip to keep it from moving side to side.

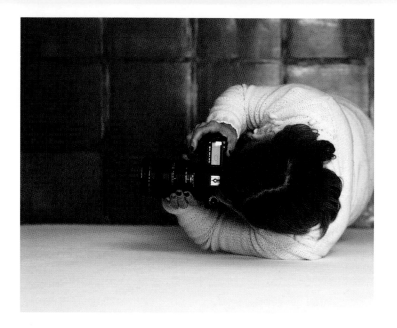

>> **Lean against a wall or other object for stability**

You can use any solid object to help steady your camera. Brace your camera against a wall, or brace your body against a wall or other object for stability; adding another leg = a tripod!

You can place your camera on a table or chair and position it to be able to adjust your controls. In fact, you'll find a lot of objects can help you get the shot you want. And as we will discuss later, you can bring a small beanbag to set your camera on to steady it.

One other tip to help minimize camera shake, do what sharpshooters do: press the shutter as you exhale, you can feel that's when your body is more relaxed.

GETTING EVEN FRIENDLIER WITH YOUR CAMERA

My final piece of advice for getting to know your camera even better, once you have mastered the basics above. Since there is much more to know about your specific camera, find a book written for it that gives accurate information. You can find a highly rated one for your camera on Amazon. There are a series of "Compact Field Guides" that are very good, and you can pack one in your camera bag (along with your AYP book!)

Manuals have become progressively more complex and thus harder to use as a reference, so I suggest using them in conjunction with a Field Guide, or else as a last resort if you can't find such a book. In any case, try out what is being discussed and stop to make your own tests, etc., while you read. The idea is to put the data into action!

CRASH COURSE/SUMMARY

1. Know your lens:

 A. How to rapidly focus.

 B. Focal length (how wide or telephoto it is). If you have a zoom you can change this back and forth easily.

 C. Manual or Auto Focus, use manual focus for now.

 D. Aperture, letting in more or less light and controlling your depth of field—the distance within which objects are in focus or not.

E. Keep your lens clean, blowing off dust first.

2. Know your key camera controls:

 A. Shutter speed, to stop action or show motion.

 B. Adjust ISO, to control the sensitivity to light.

 C. Work with aperture, shutter speed and ISO to dial in to your correct exposure.

 D. Use the highlight alert to avoid clipping and adjust "exposure compensation."

 E. Shoot in RAW so that you are able to make important adjustments in processing.

3. Hold your camera with a steady but relaxed grip, with arms braced against your body and fingers free to make adjustments.

4. Use tripods to add stability, uniformity, and sometimes just to be able to look more deeply!

5. Know how to find a support when you don't have a tripod with you.

6. And above all, practice, practice, practice and shoot, shoot, shoot.

7. And remember to read your manual (or even better, a field guide written for your camera!)

CHAPTER 4

CAPTURE: BLENDING VISUALIZATION WITH KNOWING YOUR CAMERA

"TO ME, PHOTOGRAPHY IS THE SIMULTANEOUS RECOGNITION, IN A FRACTION OF A SECOND, OF THE SIGNIFICANCE OF AN EVENT AS WELL AS OF A PRECISE ORGANIZATION OF FORMS WHICH GIVE THAT EVENT ITS PROPER EXPRESSION."

— HENRI CARTIER-BRESSON

Whether you've visualized your image over minutes or even hours, or in fractions of a second, how you capture it is the next step of the cycle of photography.

Before we dive in to how you capture your image, let me point out two traps I've seen photographers get hung up in that I'd like to help you avoid:

1. The equipment trap: Yes, you need to know how to use your equipment, but to "geek out" or obsess over your equipment is a trap. Give a great photographer any camera and they will come away with good photographs. The reverse is not true – hand the most excellent, latest-model-wonder to someone who doesn't know how to create a photograph, and fantastic images won't magically appear from the camera. This holds true in any field: give a few basics to a great chef and they will make magic.

2. The other trap is getting hung up in the "rules" of composition rather than training your eye and using your skills of visualization as we have previously covered. There are guides that can help you

compose, but they are not "rules" or inflexible laws, but rather tools that you can choose to use or not.

But this doesn't mean that you should go out and "wing it," either with your equipment or with composition; with both you should be fully aware of your key tools and able to use them to create photographs that you love. Just keep in mind that composition is a lifelong learning adventure of finding new ways to tell your story, constantly reinforced by your power of observation and by constantly exercising your power of visualization.

There is one other point I'd like to bring up, called the "Creative Gap," so named by Ira Glass, the host of the radio show, "This American Life."

The gap is between what you want your work to look like based on your vision and how it ends up looking. Every artist goes through this – you hear a piece of music and sit down to play it on the piano or guitar, and boy, what happened? You encountered the gap! The key is to not get discouraged, any more than you would when you start out on a long hike and you don't make the 8-mile trek in an hour! You just need to keep putting one foot in front of the other and persist.

In the case of photography, follow the steps of visualization, learn your equipment, and learn to capture. Then look at your results, critique yourself or get help from a reliable mentor, learn and practice and go out again. And as with shampooing your hair, repeat!

And don't buy the idea that it takes so many thousands of hours or so many years to close the gap. It is simply a process and you can move forward rapidly if you apply yourself to it. Jimmy Chin, the very talented photographer of extreme outdoor and human endeavor, got his start through a fortunate accident: He took one frame with a friend's camera, and that photo was then bought by the friend's client. Okay, so Jimmy is at the extreme end of everything he does, but the point is, don't peg your skills to time, rather push yourself – learn, shoot, and practice – to close the creative gap!

COMPOSITION GUIDELINES:

Here is a big clue for composition from photographer Edward Weston:

"TO COMPOSE A SUBJECT WELL MEANS NO MORE THAN TO SEE AND PRESENT IT IN THE STRONGEST MANNER POSSIBLE."

Here, "strong" means "powerfully affecting the mind, senses, or emotions: his imagery made a strong impression..." (Oxford American Dictionary). Your goal is to see the subject, then visualize the strongest way of seeing it that captures the vision, emotions, and senses that you saw.

As a note on creating "strong" images: just as you create a photograph, you must make time to advance your photography – don't wait for it to just happen on its own! When you go out to photograph, do so with a clear-cut and strong purpose for what you intend to achieve as an end result.

Here are some of the key tools that you can use to capture strong images:

The first tool is **framing**. Framing means two things:

1. Putting an edge or border on your photograph by finding and including a natural frame, such as a tree or a branch, or the edge of a building. This frame can help the viewer focus on what you want him to see, and helps to add depth, layers, interest, and even contrast to your photograph.

 When I was first learning photography, my Uncle "Sambo" taught me this simple point of framing, and immediately I saw an improvement in my photographs.

Here is an example of framing with a border by using the fence and the tree branch, which even echoes the slope of the mountains down to the sea.

» **Fence, Big Sur CA, Marc Silber**

Doors, windows and other man-made objects also make very handy frames, as you can see with this worker in Mexico:

» **Fausto, El Zopilote, Mexico, Marc Silber**

1. The other definition of framing is to fit what is happening out in the scene into the frame of your camera so that you have "...a precise organization of forms which give that event its proper expression," the result Cartier-Bresson mentioned earlier.

2. In this case of framing, you may not have an edge or border that you're working with, but by using your camera frame to select what you want to include in or exclude from the image, you will direct your viewer's eye and tell the story you want to convey. The point is to consciously and deliberately fill the frame, and as multi-award-winning travel photographer Bob Holmes told me, you are responsible for everything in the frame, so be sure to scan it thoroughly, including the edges.

Remember in Chapter Two I told you to go out using your hands as a frame to train your eye? Make time to go out and practice your framing.

POINTS OF THIRDS AS A GUIDE FOR COMPOSITION

The idea of using points of thirds in composition was first developed by an engraver named John Thomas Smith in about 1797; it has often been referred to since then as the "rule of thirds." As I said earlier, it is not a rule, but a guide one could use or not. The idea that Smith put forth was that you could break an image into lines of thirds as an aid to composition. By placing elements on one of the lines, he found you might achieve a picturesque or harmonizing composition. As he said,

> "...for example, in a design of landscape, to determine the sky at about two-thirds ; or else at about one-third, so that the material objects might occupy the other two: Again, two thirds of one element, (as of water) to one third of another element (as of land)..."

In other words, by using three horizontal and vertical lines (see example below) and simply have one third occupy one part of the frame, and two thirds (sky, water, or objects) occupy the other.

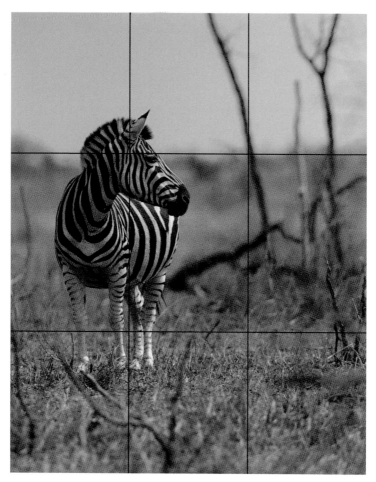

» **Kruger National Park, South Africa, David Smith**

To help with this, set your camera for "Grid View," both in the viewfinder and playback. If you have the option, set it for a 3x3 grid to keep it simple (refer to your Field Guide or manual).

David Smith, award winning outdoor photographer, who you'll meet in Chapter 7, gave this advice about composition images of animals, but it could apply to any subject:

Use your grid view in your camera to place a subject on a point of thirds, which has a really strong dynamic pull to our eyes. You might have the animal looking into the frame or looking across the frame. If the animal is looking to the left, leave more space on the left for it to look into, same of course on the right. If the animal is looking up, put them low in the frame looking up at something.

Try placing what you want to draw attention to on the intersection of two lines, as you can see that David did with the zebra's face. As you can see, that has a dynamic pull – your eyes are just drawn there.

ANGLES

The next set of tools that actually flows right from your framing is the angle you shoot from.

There are two basic ways you frame an image: Portrait and landscape. But these two names should not peg you into thinking just in these terms.

Many great portraits are framed as landscape, especially when it comes to "environmental portraits", which means to capture your subject in their environment, often showing their signature accoutrements. Those in the photo may have a relaxed or even moody expression (rather than posed with a smile), as you can see in this image by Bob Holmes of a farmer in Cuba.

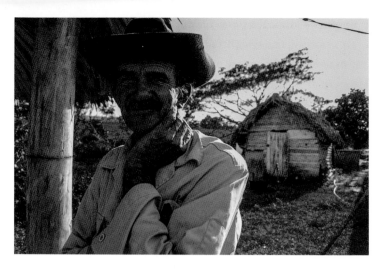

» **Vinales, Cuba, Robert Holmes**

My favorite photographer of environmental portraits is Arnold Newman, and one of my favorite examples is his image of Igor Stravinsky. Look it up, and notice how he is able to capture an entire story of this great musician with a landscape that positions him perfectly and geometrically with his instrument.

And of course, the reverse is true, many great landscapes have been captured as "portrait" configurations, including the peppers previously noted by Edward Weston. (I suppose you could consider it a portrait of the pepper?)

Now don't stop there, you can turn your camera to any angle you want to help tell your story. You can see that I turned the camera at an angle to accentuate the geometry of this image:

» **Peninsula School, Menlo Park, CA, Marc Silber**

There are many other angles you can shoot from, and each one will change how you portray the subject to your viewers:
Here are some points from the book *How to Shoot a Movie Story* (by Arthur L. Gaskill and David A. Englander), which are totally applicable to still photography:

"The Power of Angles"

"Camera angles can control an audience's attention and reactions to a remarkable degree. They can emphasize what you want your audience to see and how you want them to see it.

"Shrewd 'angling' of the camera will enable you to control background and foreground and eliminate any feature that distracts from the subject."

The text goes on to outline these angles:

- Flat angle (taken "head on" such as the camera facing the front of the subject), is often just that "flat," leaving the subject looking two-dimensional rather than "round." They can also give the illusion of reducing the speed of the subject.

» Florian Schulz

- High angles (camera looking down) reduce height and size of the subject and slows down motion, creating superiority for viewer.

» The Start, JohnTodd.com

- Low angles (camera looking up) do the opposite,
 by exaggerating the subject's height and give the feeling
 of motion being speeded up: the subject commands
 attention. There is drama and excitement in their actions.

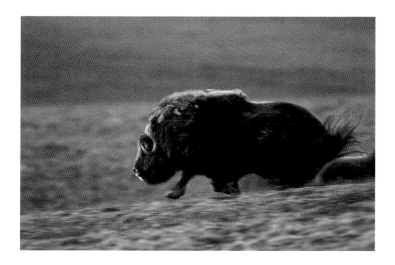

» **Florian Schulz**

- Shooting a side angle of the subject can give depth and perspective to the subject and can also give the illusion of increasing speed of the subject.

VIEWPOINT

Another point about choice of angles is selecting the viewpoint you want your audience to take. For example, supposing you were taking a photo of your kids on bikes, racing along. If you chose a flat angle, you would leave your viewer feeling like a spectator, removed from the action. But what if you crouched down and moved along with them? They would now have the viewpoint of the kids in action. See how shooting the monks from a high viewpoint on the next page allows you to view them, along with the variety of bowls they are choosing from.

» **Monks, Bagan, Myanmar, Robert Holmes**

By changing the viewpoint of the camera, you can shift your viewer to various points of view of the scene you're shooting.

When you go out and shoot, try not to look just from your perspective standing straight up or sitting down. Remember, your best friends are your feet, so move around, changing angles and viewpoints. And stay limber! Crouch down low, or lie on the ground! Reach high or climb up a ladder to get a high angle shot. Turn your camera on an angle. Digital images are cheap; don't hesitate to shoot from all sorts of angles.

A few years ago I was shooting in a small village called Santa Pau in Spain. I photographed all afternoon, and at dusk the light was failing so it was time to leave. Bending down to get into the car, I looked up and saw that the cloud formations in the sky were very intriguing, and told my wife and friends to "hold on," I had a

few more shots to get. With the clouds now visualized, I took this low angle shot looking up, capturing the buildings and sky. The moral here is always look for that unexpected angle!

» **Santa Pau, Spain, Marc Silber**

REMOVE DISTRACTIONS

Learn from the painting masters how you can emphasize what you want your viewers to see, and remove or de-emphasize what you don't want them to see. If you leave things in the photo that are distracting, hoping to "Photoshop" them out later, you may be disappointed. I would rather see you "crop" and compose in the camera, meaning take control of your shot and change angles or even change the subject around until you get a clean shot. You are the one who is in control of the photograph, so remember what Bob Holmes said: you are responsible for everything within the frame.

BE READY TO MOVE FURNITURE!

If you're taking an environmental portrait and there is clutter – say on Stravinsky's piano, that I mentioned, photographed by Newman, he had a stack of music, an ashtray (he was known for his smoking), etc. – move it!

Arnold Newman no doubt did some housekeeping with that image, as there is nothing in the frame but his subject and the piano, leaving it clean and powerful. Newman was quoted as humorlessly saying, "Photography is 1% percent inspiration and 99% moving furniture." I often quote that to my team on shoots as we lug couches, chairs, and even plants and trees about to make the scene look like what we want!

Don't be a spectator to the scene. You are the producer, director, camera operator, and assistant all rolled into one. Move things around until you see what you want and add more or less

(though usually it's best to lean in the direction of less). And of course never have things behind your subject sprouting out of their head – not a good look!

LIGHT IS A LANGUAGE

Since photography means "light writing," light is your basic tool that you are working with. Joe McNally, an outstanding master of photography and thus of light, told me, "Light is language, think of it that way."

The first step of really learning the language of light is to closely observe it. As we discussed, this begins with your study of the masters, to see how they used light, what their light sources were, and how did these strike their subjects? Let's look at this painting by Johan Vermeer, the master 17th century Dutch painter who painted simple everyday life, using mainly the same two rooms of his house and often the same subject (a great place to start: no elaborate studio, make up, lights, etc.)

» **Johannes Vermeer, Milkmaid**
 Source: Rijksmuseum, Amsterdam

Look closely at this painting and take note of what you see: One
light source coming through the window, which lights the side of
the woman facing it, leaving the left side of her face in shadows.
The cream wall behind her is hit by the light, giving fantastic
contrast to her top and blue apron. The objects in the room are
only lit from the window and by light reflected from the wall and
are bright or shadowed accordingly.

A very rewarding exercise, both in learning light and composition, is to find a room similar to this in your home, dorm, or apartment, recruit a willing subject and simply reenact this as a photograph! One light source, one subject, you and your camera!

Get in the habit of observing light wherever you are – inside or out. What is the main light source, what are the secondary sources, where is it being reflected from, etc? Wedding and portrait specialist Bambi Cantrell showed me how she sizes up light in a room by holding her hand out and noting how light strikes it, then turning her hand to see any changes from other light sources.

Bob Holmes told me that in addition to always paying attention to light, you have to know how your camera reacts to that light. "It's not just that you see what light does on the subject, it's knowing how your camera records it." In order to know this, you have to practice and shoot under different lighting conditions so you know exactly what the end result is going to look like. He talked about two kinds of lighting that he often uses; one type is light that is completely inside the frame, such as this photograph taken of a group of indigenous people around a fire.

>> **Bagan, Myanmar, Robert Holmes**

The other example of lighting he uses extensively is Vermeer lighting, as we just discussed. "It's very soft and very flattering." He loves Vermeer light, particularly against a dark background: "It always looks great!" Another reason for you to really practice this technique and have it handy whenever you can employ it.

There is a third type of light, which is "bouncing around" like midday light, hitting different surfaces. It's important to be able to work with all three, and of course their many variations.

As he is a travel photographer, Holmes doesn't want to pack a lot of equipment, so rather than illuminate the person with lights, he moves his subject to the light source. What we discussed about creating the photograph and being responsible for the set-up applies even more to your lighting. Don't hesitate to move your subject closer to or farther from a window or other light source to get the look you are after.

One final point here, just as you want to be sure the subject's eyes are in focus, unless you are going for dark moodiness, be sure their eyes are well-lit, again moving them around or using a reflector as we'll cover in a moment.

SHOOT DURING THE "GOLDEN HOURS"

We love the "golden hours", which are generally half an hour before and after sunrise and half an hour before and after sunset. This is when the light is warmer and softer, and it can add more dimension to your image. When you're traveling, you'll want to get up early to capture that light and plan to go back out again at the end of the day – save your shopping and sightseeing for the hours in between!

In any case, try to avoid shooting outside at midday, as you'll get some harsh shadows. Bob's tip for shooting at midday is to move your subject into a shady area, out of the harsh direct light. His image on page 96 is a good example of this.

When you don't have enough light and want to eliminate shadows or make sure the eyes are well-lit, your can use light reflectors. Just as you saw that with Vermeer the wall acted as a light reflector, there are many man-made and natural reflectors you can use: Light bouncing off sand at the beach, off the sidewalk, or off a ceiling, for example, can serve to fill in and reduce shadows. You can even wear a white shirt and reflect light back on your subject. Holmes said he uses newspaper as a reflector. And of course you can buy reflectors of various sizes and use them.

The steps are the same: Look at the existing light source, notice your subject and whether shadows need to be filled in, then use a reflector, moving it about until you get the desired effect.

As far as artificial light goes, I am only going to briefly discuss this, as there are many excellent sources and courses on it. I recommend that you stick with natural light until you really have it down cold before you move on to artificial light. The same rules apply that we went over previously: Really be aware what the light is doing and how your camera reacts to it. Start with one light source, moving it or your subject until you get the look you want. Then continue to build from there with other lights or reflectors.

Putting it all together, you know the mantra: After you study, get busy looking and practicing. Then really examine your results (on a computer) and go out and practice some more.

PUT PEOPLE AT EASE

When you're photographing people, you should keep your attention on them instead of fumbling around with your camera settings. A key point that celebrity photographer Matthew Jordan Smith told me is that it's not enough for the subject to look good; you want them to feel good, and that starts with you. Keep it upbeat when you're taking pictures, talk to them and engage them. An important "don't" he mentioned: don't keep looking at the back of the camera after each shot – keep your focus and communication with your subject, not with your camera.

»

» Shoot while talking, Sierra Madre, Mexico, Marc Silber

If you're nervous about photographing them, your subject will sense it and feel uncomfortable. On the other hand, when you've practiced what we've gone over and keep your "set" upbeat and alive, your subject will have confidence. Michael recommends music on the set to create the mood you want.

When I'm traveling and photographing the people of a village or town, they are often so unused to being photographed that they freeze up, standing stiff and posed. I'll shoot the posed shots, but I continue shooting while I'm talking to them, with the camera not held to my eye but still pointed at them, getting the natural shots as they think they are just talking to me.

Another trick that photographer Hunter Freeman told me is: if you're shooting someone who is sitting or standing and they become stiff, have them get up and turn around, and then right away when they sit again, start pressing the shutter. The whole idea is to take their attention off the camera and help them feel comfortable and relaxed with good communication.

CRASH COURSE/SUMMARY

1. Be able to compose a photograph to give it its "proper expression."

2. Close the creative "gap" with consistent practice.

3. Compose by seeing in the strongest way possible.

4. Frame your photographs by putting an edge on them or filling the frame for best results.

5. Use angles to tell the story you want. There are many to shoot from, get to know them well.

 A. You can shoot a portrait in landscape and vice versa.

B. You can turn your camera any way you want: on edge, up, down, high or low.

C. Looking down on your subject makes the subject appear smaller and slower, and the viewer seems superior.

D. Shooting from a low angle looking up makes the subject appear larger, commanding attention.

E. Side angles give depth and exaggerate speed.

F. Along with angles, you can shift viewpoints for your observer, depending on where you point the camera from.

6. Be fully in control of creating the photograph – remove distractions and move things around as needed.

7. Learn the language of light:

A. Really observe light, study the masters again.

B. Look at light wherever you are – hold your hand out and see how it hits it.

C. Know how your camera records light – shoot and observe.

D. You can have light from inside the frame.

E. Or from a single light source such as a window (such as "Vermeer" lighting).

F. Or bouncing around from various light sources, such as outside midday. In this case, take your subject to a shady area.

G. In any case, be willing to control the shot and

move your subject around to capture the best light.

H. Get out and shoot in the "golden hours" before and after sunrise and before and after sunset.

I. Use light reflectors to control light and make sure your subject's eyes are lit. There are many easy reflectors you can use, even a white shirt or newspaper!

J. The same rules apply to artificial light, start with one source and build from there. Look at how the light hits your subject and adjust.

8. To make people feel comfortable, you have to be comfortable yourself.

A. Communicate with and engage them to help them feel comfortable.

B. If they pose, keep shooting but don't look through the camera!

C. When people get stiff, have them move around and relax and then shoot them again, right away.

Soft Proofing

CHAPTER 5
PROCESSING YOUR IMAGES

"A GOOD PHOTOGRAPH IS ONE THAT COMMUNICATES A FACT, TOUCHES THE HEART, LEAVES THE VIEWER A CHANGED PERSON FOR HAVING SEEN IT. IT IS, IN A WORD, EFFECTIVE.

– IRVING PENN

Now that you have recorded your images onto a memory card, your next step in the cycle of photography is to process or develop them.

I told you that when I first really became a photographer was in the 7th Grade when I learned to use a darkroom. This opened a whole world of possibilities to me, where before I had taken rolls of film to the drug store, dropped them off, and a few days or a week later excitedly returned to see the result – only to be deflated by the lack of life that I saw in them! Surely these were not my photographs; some machine had sucked the life out of them, leaving them limp, drab, dry, and lacking the glorious vision I had when I pressed the shutter.

I was right to rage against "the machine," which in this case was an automated developing and printing monster that sucked in film rolls by the thousands and spat out the most middle-of-the-road renditions that were barely tolerable. There was no thought about creativity or choices to be made, they were all simply "processed" the same way, which resulted in the photo version of processed "cheese" – that gooey, plastic, awful-tasting stuff that doesn't deserve to be called cheese!

My adventures in the darkroom taught me that I could control the entire process of development and printing, allowing me to

change the final outcome in so many ways: I could change the size of the print and crop it according to what I wanted to see or not. I could control exposure, making prints lighter or usually a bit darker than those drugstore versions that always looked washed out. But by far the biggest joy for me was to discover that I could control contrast, the degree of differentiation between darks and highlights – now that was what made my images pop! What I saw before as muddy was actually low contrast coupled with poor exposure. Now I was able to control these key points and create photographs that I loved.

Keep in mind that visualization carries through the entire process and very much comes into play at this stage of processing. You want to be able to control the way your image looks and even feels to your viewer. Instead of wizardry in the darkroom, I use the magic of Adobe Lightroom to process my images.

Why Lightroom? Adobe invented the "digital darkroom" and has worked constantly to improve its capabilities. I started using Lightroom when it was still being tested in 2006; back then it was shipped with no manual or training, so learning was a bit of a fumbling process of trial and error. But I soon learned that it had enormous potential and stuck with it. Over the past several years there have been many, many advances along with fantastic training that is now available, making Lightroom the essential tool in your image processing stage.

Before we get started, I would like to say that in addition to my own experience with Lightroom (we'll call it Lr from now on), I have learned a great deal from Scott Kelby's books. Scott is simply the master of Lr, and I recommend that after getting

the basics from this chapter you also order his Lr book on our resource page. Many of the points that I'm going to go over with you I learned from his books, also of course from my own use and by going to Adobe's Support Center, especially their videos, which you can access directly from Lr > Help. (Speaking of videos, I have a six-minute Lr introduction in the resource section, so start by watching it, on AYPClub.com, again on the resource page.)

Now let's get started and go through the work flow I recommend. I am only going to give you the basic outline to get you rolling and then I want you to hit the resources I just mentioned later to dive deeper, but these will take you far and give you joy in their use.

When I was a film photographer, I thankfully learned very early on to keep my negatives in good order. I keep them all by film roll, neatly filed with their "contact sheet" that shows the entire roll of film in tiny images on one sheet of photo paper, as you can see in this example. (They are called "contact sheets" because you simply lay the negatives in contact with the printing paper and expose them with no enlargement.)

>> **Contact sheet with jumping photo in upper left**

But when I switched to digital, I forgot this and just began to "dog pile" my images into my computer in a sort of open filing system – this worked for a while, but not so much after I amassed a few hundred images. Then I had a problem.

This is the first point of order and help that Lr brings you: it is divided into parts called "modules" which simply means separate units of Lr. It's no different than having a refrigerator and shelves in your kitchen to store your food (storage module) before you prepare it in another module called a stove.

Lr calls its storage module the "Library", which is very logical. This is where you're going to import and arrange your images before you go to the next module, which is aptly named "Develop."

(If you need step by step directions for importing your images into Lr, see Appendix 1.)

STAYING ORGANIZED IN THE LIBRARY

In this section I will go over the work flow that Scott Kelby suggests to sort through your images, which I have found to be very helpful.

Now that you have your images in the Library, you need to be able to sort through them to decide which you want to keep and which to discard, but especially the "selects" that you'll be developing.

As I mentioned about my darkroom work flow, the very first thing I would do was to print a contact sheet, which was simply a small version of the negatives, but since it was printed, you could see it as a positive. I would look through these to see which I wanted to print and then mark which ones to work on further and which to ignore using a marker.

In Lr you do basically the same, except it's much easier. Let's start by sorting through a folder that you're most interested in, no matter how old or new it is.

Be sure to actually do all the following steps as you read them: don't try to do them in your head – it will explode with too much data!

» Grid view of Lr

1. In the Library, click on your chosen folder in the left panel under Folders. This should open a grid (if not type G), and you'll now see the grid like the one above. On the bottom right corner of the grid (below the last image), there is a Thumbnail slider to adjust the size. (I keep it about in the middle.)

2. Tap on the top left image to open it in "Loupe" (meaning it magnifies the thumbnail by opening the full image).

3. Now starting with that image, begin sorting: If you see it's no good and you want to toss it, hit "X" and Lr marks it as a reject. When you see one you like, hit "P" to mark it as a "Pick." Just hit the right arrow key > to move to the next image.

4. When you're done having your fun, let's first dump the rejects: At the top Menu, go to Photo and go all the way

to the bottom: "Delete Rejected Photos" It will ask if you want to delete from your disk or just from Lr; I say if you don't like it, delete it from your disk! Now you've purged all the ones you really don't want.

5. Now let's get the Picks: Go to the bottom right where you'll see "Filters off" and click on it, and then click "Flagged" to bring up all your picks (the other ones that you haven't committed on just stay in their folder in the Library.)

6. Now let's do something really cool to focus just on your picks by making a collection just for them: Go to Edit > Select All. Now go to the top menu and select Library > New Collection.

7. This brings up a dialog, "name the collection"; I call it the same name as the original folder + Selects, for example "Dailies* Select." Leave checked "include selected photos" and "make virtual copies" (which means you'll be editing a copy), then hit Create!

 *I have a folder called "Dailies" that are shot on a smartphone day to day.

8. Now look down on the left panel, near the bottom you'll see "Collections" and your new collection will be there!

What I like about this process is that it keeps your folders clean and you know that anything you want to process will be in a collection.

Now that you've done the sorting on that folder and have a new collection, we can move on to processing; this is where the real fun and magic begins!

We'll go through some of the basics of the Develop module in Lr, and you can explore many more techniques later, but really get these basics down cold first.

VISUALIZE BEFORE BEGINNING PROCESSING

Before you and I dive into the technical steps of processing, let's take a moment to look at the creative aspects of where you'll be going with your image. Before even moving any sliders, you'll want to look at your image and what you visualized for it, which can also be a fresh new visualization for it.

Go to a "Select" in your favorite collection. Double-click on it to open it in Loupe view. Look over that image, and recall how you visualized it. Then look it over again and take a fresh look at how you want to create it. For example, do you see how you might want to crop it, or do you want to make it a black and white? Take this time to look it over as you might look over a room before you start to paint and design it: how do you want to make it look, given what you've got right in front of you?

One thing you'll want to be sure of is that you're getting an accurate view of your image, so like you would clean your windshield and remove your sunglasses to see the sights clearly, google "calibrate display [mac or windows]" and follow directions. With that done, we'll go to your basic processing.

BASIC PROCESSING STEPS:

» **Develop Module**

Hit D to open the Develop module. This is your key module, so let's get oriented. First you should know that Lr is "non-destructive" of your original images. This means it never actually makes changes to the originals, so don't worry about messing things up! If you had this when you were a kid, wouldn't it have been amazing that time you scribbled happily on the walls with crayons, but your mom wasn't so thrilled when she came in? What if you could just press a "back" button and restore the clean wall?

On the left panel at the top you'll see the "Navigator" window, this allows you to move around in the image. Just leave it at "Fit" to fit in the large viewer without cropping.

Below it on the left is "Presets" for developing, which we're going to ignore. I want you to learn to make the adjustments manually, just as you did with your camera.

Below that is "Snapshots." You can save an edit and easily come back to it again, which can be handy. I usually just use the "History" panel, just below it. This allows you to jump back as far as you want in your editing. So if things go really wrong, you jump all the way back to import and start all over (at your clean wall!)

Below that you can also access your collections, which is another handy reason you made your collections of Selects. (Lr has many ways to do the same thing, so just find what you're comfortable with and stick with it.)

Now, let's get into developing on the right panel:

At the top is your "Histogram" which shows what your image looks like on a graph in terms of exposure. The word histogram is derived from the Greek *histo* meaning mast (or vertical lines) and *gram* denoting something recorded as a graph. So in our case it is an *indicator*, a graph showing the range of light of your image.

Your histogram is a very powerful way to graphically see the changes that you need to make, and to track changes as you make them.

On the far left side of the histogram are the darkest parts of your image; moving to the right are the shadows, then midway are the mid-ranges and to the far right are the highlights. The object is to avoid "clipping" of information at either end (to prevent loss of detail in your image), and to have a smooth "hill" in between, with information fairly evenly distributed.

Here is an example of a histogram that shows clipping on the right (highlights), and left (shadows) and the mid-ranges are bunched up on the left. Now see how it looks when properly adjusted.

There's another cool trick: do you see the boxes with an arrow in
them at the top left and right? Click on them to reveal clipping
in your image, blue for darks and red for highlights. These
indicators will help you keep track as we move sliders, creating
the look you want.

» Click on arrows to show clipping

Use your histogram as an indicator, but don't get glued to it
any more than you would have your eyes glued to your car's

instruments – see the scenery too! And use your own judgment as to how you want to *create* your photograph.

» Use your camera's histogram to avoid clipping

Digressing for a moment, now that we've talked about the Histogram, you may have noticed that you also have one in the playback in your camera (refer to your Field Guide to set it up for brightness/luminance.) In watching the "highlight alert," your objective when exposing an image in your camera is to avoid clipping of highlights on the right, known as "exposing for the highlights." Now you have that information to work with in Lr. If you look at your camera histogram and see that there are lines going off the right, then adjust your exposure compensation, just as you did with the highlight alert.

Now back to Lr, the area we're going to look at first is the "Basic" panel, where you set your exposure and optimize your image while watching the histogram. I usually start at the top of this panel and work my way down. The top says "Treatment" which lets you

go from Color to Black and White, but don't use that. There is a much better way to make your image black and white that we'll get to later.

The next area is for White Balance. This is to adjust your image so that you get a proper (balanced) white that matches what you saw when you captured the photograph. Have you ever seen a photo that had its colors off, like too much blue or yellow from shooting under florescent tubes? That means its white balance was off, which you can correct here.

On the right side of "WB" it should say, "As Shot" (if not, click to change it to As Shot). Now go just to the left of "WB" and click on the eyedropper. Now move your eyedropper over something in your image that is light grey. Notice that the small navigator window at the top left changes as you go to different areas. This helps you select the right area. Try it and you'll see that if you go over an area that is not light grey, it goes blue or orange, yikes! Just keep looking for a light grey area, and when you have it, click on it and you'll have your white balance.

If you don't like the way it looks, start over. One thing that will make this easier is to uncheck at the bottom left under your image

where it says WB: "Auto Dismiss" – a feature I don't like to use because it puts the eyedropper away each time you click on it.

With your WB set, you can now go on to the "Tone" panel. Tone here means how light or dark your image is, including shadows, highlights, and how much contrast it has. Tone comes from a Greek word meaning "stretched," which if you think in terms of your histogram, you want your image properly stretched, not bunched at the ends (clipped) or too bunched to one side, but aesthetically placed the way you want it to look!

You'll see there is "Auto" which is Lr trying to set the tone based on the histogram. Like any auto setting, sometimes it gets it right, but I'd rather have you learn to do your settings manually at this stage.

Remember my breakthrough as a photographer when I first learned that I could control the exposure and contrast of my print? That's when I discovered that I could make a previously drab or weak photograph "pop" by increasing its contrast so that I was getting more pronounced blacks and whites, thus giving it good tone by stretching out these values.

I will then set the exposure briefly, but I know I'm going to come back to it later to make final adjustments. Remember, this is called the "Develop" module, so you're going to have some back and forth on your sliders as you develop and fine-tune your image.

I then invariably increase the contrast. When you move it to the left, you'll see the image losing contrast and getting muddier, and it gets bunched up in the middle of your histogram. Move it to the right to increase contrast, and see it getting stretched out. But just as in seasoning food, sometimes a small adjustment is all that is needed.

Next look at your highlights, and where are they hitting on your histogram. With the triangle clicked "on" at the top, if are you seeing clipping (red), adjust it accordingly. I generally push it as far as I can on these tone controls until I hit clipping and then back it off a bit. But this is where your judgment comes in, as I said, don't just go by the indicators – what do you want to make your image look like? You may not want texture in the dark areas to show, so you would want those areas to be clipped, for example.

» **Badly clipped on both Highlights (red) and Shadows (blue) notice the Histogram too**

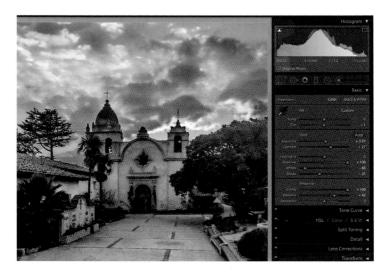

» **You'll see a tiny bit of clipping in Shadows, which I'm OK with, since I don't care about that detail and wanted to enhance darkness in clouds.**

Now for blacks and whites, here's another fun trick: Hold down the Option key (on a Mac, or the Alt key on a PC), and you'll see any clipping as you move these sliders.)

As I said, I go as far as I can on each until I hit important clipping (somewhere other than on detail that has no value to me, like the inside of a dark space, which I may want to lose anyway).

Now we're down to the "Presence" controls, which in this case means the distinctive qualities of the image. (When you say a person has a lot of "presence," it means they are distinctive and you really "feel" them. This area helps you establish the feeling of your image.)

The first is "Clarity", which adjusts your mid-tone contrast, helping to bring out depth and texture. Slide it back and forth and notice what's happening on your histogram. Now on landscapes, that texture is usually desirable, but going too far to the right (again as in cooking) can give you too grainy or harsh a look. But let's say you've got a portrait of your grandmother, then you may want to move to the left to soften her face.

Next is "Vibrance:" the word comes from Middle English meaning, "give out light as if by vibration." What it does is control your mid-tone colors, which can give good vibrations!

This slider is smart! It adjusts the dull (mid-tone) colors the most and those already saturated the least.

Below that you have "Saturation", which changes the overall amount of color in your image. Slide it back and forth, watching your histogram – again, a little goes a long way. But don't go to the left to fully de-saturate to make a black and white, I'm going to show you how to do that, I promise!

WRAPPING UP YOUR BASIC EDITING:

» **Lens correction panel**

Go down to the Lens Correction panel and click the triangle on the right to open it. This will fix lens distortions (aberrations) and some other things if needed. Click on the two boxes below "Profile." It should select your camera's lens, if not, select the make and

model of your lens. (If you don't know what those are, just take a break and grab your camera, it will be written on the inside front ring of your lens.)

If your image is off level, the easiest way to fix that is to go down to "Transform" and click "Level." If it does a good job, leave it, if not, click "off" and we'll fix it manually.

That's as far down as we're going in the Develop module for now. We've covered almost all of your basics except the tools at the top. ("But Marc, what about all the other stuff in the Develop module – don't I need to know that stuff too?" Just learn these basics first, and then you can dive in deeper, okay?)

Let's go back to the top of the Develop Module. Between Histogram and Basic, there are two tools we should take a look at:

At the top left is the crop tool, which is pretty self-explanatory; just grab the vertical or horizontal sliders at the edge of the image and move it to your desired position. I crop to remove parts that are distracting or really don't help tell the viewer what I want them to see. And sometimes I might want to adjust the points of thirds that we discussed in the last chapter.

Once you have the crop you want, just hit enter to confirm it. If you don't like it, hit Command-Z (on a Mac; on a PC: Control-Z) and you can undo it and set it again. (You can also go back any time to your History panel on the left.)

If you need to straighten your image and weren't able to do so above, look in the crop dialog for "Angle" and slide it back and forth to level it, using the grid lines as your guides.

The next is the Spot Removal tool, to the right of the crop tool (a circle with an arrow going to the right.) This tool is super handy to fix any spots or even distractions you may want to get rid of. Click on it and you'll see a dialog. Set size a bit larger than the area you want to fix. Leave feather at 0 and opacity at 100, and click on "Heal" on the top right. (I use heal almost exclusively as it will blend in with the area you're fixing, where "Clone" will copy an area to fill in.)

Find a spot that you want to fix and click on it. You'll see a second circle appear, called the "source circle," which shows you where Lr is sampling from. Most of the time it does a good job, but you may need adjust it: Click on the source circle to move it around until you get a better match, and stop when it looks correct.

You can even remove larger areas by simply clicking, holding, and dragging your cursor over the larger area. The same may apply where you need to adjust the source area to get a good match.

BLACK AND WHITE

I started as a black and white (B/W) photographer and still love to process my images as B/Ws if I visualize them as such. Sometimes there is important color that I want in the image, or on the other hand, maybe there's a lack of color, and I want to really emphasize the form or vista that I saw as a B/W. Here's the cool way to do it. Google owns a collection of cool processing tools called the "Nik Collection" (Google it). Click on

it and you'll see a link to download their free software.
(Yes, Google bought the company and now gives it away for free!)
Follow their instructions to install it on your computer for Lr.

>> **Here's a recent example from a backpacking trip to the Teton
Mountains in Wyoming. Here is the original; it's okay, but
kind of a postcard**

Now in the Develop Module of Lr, right click on your image, go
to "Edit in," and go down to "Silver Efex Pro 2." It will default to
"Edit a copy with Lr Adjustments." Leave it and just hit Edit, and
it will now open the software with your image in it.

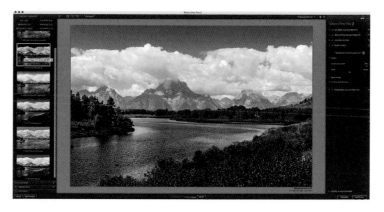

> » **And this is how I developed it as a B/W. I'm sure you'll agree
> it's much more dramatic**

On the left you'll see the "Preset Library" with lots of options.
Start with "Modern" and click on the first one. Click through
the others, and when you come to one you like, click on the star
next to it, which makes it a favorite. Once you've looked at all
the options, you can go up to Favorites and click between them to
narrow it down until you find one that you love.

To give you even more of a film look, go to the right panel and
click under "Film Types" and you'll be able to click through a
whole variety of film types. My go-to film for landscapes was
Kodak Panatomic X (I even love the name!) The only other
change at this point is that I don't want grain in my images, so I
set the grain size all the way to the right at 500.

At this point I'm good to go, so hit "Save" at the lower right, and
lo and behold, it opens back in Lr with my new edit! You can then
make any other adjustments in Lr that we've just covered.

CRASH COURSE/SUMMARY

1. Visualization carries through the entire process, from your original vision, or a fresh one when developing the image.

2. Import your images into Lr (see Appendix 1).

3. Keep good order in your Library, and use Collections for your "selects."

4. Hit "D" to go to the Develop module to develop your images.

5. Take a moment to look over and visualize your image and decide how you want to create it.

6. Be sure to work with a calibrated monitor (google for instructions.)

7. Lr is "non-destructive of your files" – don't worry, you won't break them!

8. Learn to read a Histogram, which shows you graphically the range of light of your image: Darks on the left, highlights on the right, and mid-tones in the middle.

 A. Avoid "clipping" of information at either end (loss of detail).

B. Go for a smooth looking "hill" so that information isn't bunched up in the middle or at the ends.

C. Click the triangles at the top of each end of the histogram to see clipping: blue for darks, red for highlights.

9. Work in the Basic panel from the top down:

10. Set the White Balance using the eyedropper tool.

11. While watching your histogram, set Exposure, Contrast, Highlights, Shadows, and Whites and Blacks.

12. Adjust your Clarity, Vibrance, and Saturation.

13. Do Lens Correction and Level if needed.

14. Crop and straighten your image.Get rid of spots or distractions with the Spot Removal tool.

15. Create stunning Black and Whites with Silver Efex Pro 2.

CHAPTER 6
SHARING YOUR WORK

"THE PURPOSE OF ART IS WASHING THE DUST OF DAILY LIFE OFF OUR SOULS."

- PABLO PICASSO

» Share and Start a Conversation, Marc Silber

You are now at the final stage of the cycle of photography, which is sharing your work with others. I use the word "sharing" in the broad sense of getting your work out to others, including on social media, selling it, being part of exhibits, being printed in magazines and books, etc.

"Washing the dust off" is best done when you pass along to others your vision and the feelings that you have captured in your photographs.

YOUR VISUALIZATION AS A PHOTOGRAPHER

It's important to establish yourself as a photographer; let's apply the power of visualization to yourself and your art: What genre do you most want to be known for and excel at? You'll want to clearly establish this for yourself. Look at great artists and you'll see they are primarily known for one genre.

- Henri Cartier-Bresson – Street/candid photography
- Annie Leibovitz – Celebrity portraits
- Bob Holmes – Travel photography
- Johan Vermeer – Natural, everyday life

You get the idea. Each of these artists certainly covered other genres, but they were primarily known for one. This comes down to what marketing expert Al Reis calls "branding." "A brand is a singular idea or concept that you own inside the mind of a prospect." The mind can be a crowded place with all the information we're bombarded with daily, so to establish a brand you have to "own" a position in the mind. Then others can easily grasp who you are and what you are. That's what the great artists have done, and you should too.

Take time to really visualize what you want to be known for as a photographer; what is your "brand", what do you want to own in the mind of your viewers? From there you can create an entire campaign for your art.

Your next step is to write a short bio and artist statement (or have someone write this for you). The bio should give your story briefly; you can say where you studied photography, or that you were self-taught (with the help of this book). The artist statement is a few paragraphs about your style, your approach to and love of photography, and your influences.

It's important that from here on forward you present your work as professionally as possible on any channels that you use. You're building your brand, and you want it to stand out both artistically and technically and be very well presented. I know budget can be a concern, but go for the highest quality you can achieve. And of course there are many channels that cost nothing – social media. Go for presenting your work professionally with high quality.

WAYS TO GET YOUR WORK OUT THERE:

No doubt you're already using social media for your photography, but step up your game so that you're presenting your work as professionally as possible. This includes a clear statement of your brand, for example your logo (which you can get made inexpensively), and your head shot for your avatar (your picture in social media). To establish your brand, you need to keep it simple and be consistent. If you change things around, you'll lose your branding.

Think of brands that you easily recognize. They may do or offer many things, but I bet you have one position for them: Starbucks = coffee, Google = search, Beatles = biggest pop group in history. Each established their brand with an image, logo, and their story and stuck with it. Even when they added more and more to what

they produced, as these brands have done, they still own the core position in your mind.

"But Marc," you say, "I just want to get good at photography and show my work to my family and friends. I'm not planning on being a pro." My answer is, to quote a British statesman, "Whatever is worth doing at all is worth doing well." You've come this far to improve your craft, now let's take that next step to present your work professionally to others. You will certainly be repaid for your hard work by helping others experience your art.

SOCIAL MEDIA

Having worked out your brand, make sure you are clear and consistent with it across all platforms where you show your work.

For social media, I suggest that you concentrate on showing your work on Instagram, but only publish your Lr processed work. One very cool feature of Lr is that you can get the Lr mobile app and sync it with your Lr desktop.

Once you install the app, just go to the collection you want to sync (or make a new collection called "Instagram"), highlight that collection, then right click and check the "Sync with Lr Mobile" box. Give it some time to do so and then bam!! Open the Lr app and those images are on your phone!

Pick an image to publish on Instagram, and look it over for how it displays on your phone. If it's too dark or needs minor editing, you can open the editor in the app (touch the three dots at the bottom right of your image). If it needs more extensive editing, go back to your Lr desktop and repeat the process.

Once you have your image looking how you want it to look, go through the steps to publish it in Instagram. Now write your caption; make it as descriptive as possible of the place or feeling you're conveying. Then add relevant hash tags, and add the location. Click on Facebook (and any other channels to which you want to send it) and hit "Share."

The other cool thing about Lr Mobile is that you can add an image to it that you took on your phone, and then go to Lr desktop and process it and then share it as above. You don't have to transfer images around; it's all done within Lr!

That takes care of your posts for both Instagram and Facebook.

ONLINE GALLERIES

As part of getting your brand known, you should set up an online gallery. The two I've used are Flickr and SmugMug. I recommend SmugMug, which is more professional and will allow you to add many features as you grow: text so you don't need to create a separate website, guestbook pages, etc. They have great customer service and will help you get where you want to go.

>> **A page of my SmugMug Gallery**

Whichever you use, curate your work well and put up your best images, always processed in Lr as we covered above.

Lr has a "Publishing Service" you can use to send your images directly from Lr to your gallery in Flickr or SmugMug. Here's how it works:

Go to the left side panel in your Library and scroll down below Collections, where you'll see Publishing Services. Open it. You should see Flickr and several others. Click "Set Up" on the right side and follow instructions to connect your account.

To add a service like SmugMug, go to File > Plug-in Manager, which opens a dialog. Look to the bottom left side and click on "Adobe Add-ons" which opens a web page. On the left side of the page in the middle you'll see Lr. Click on it. Then on the top row near the right, click on SmugMug and click on the blue button "Free" to acquire it. Now look below that and click on "Where to find it" for install instructions, and follow those.

Once your service is installed and set up, go to the Collection where you have an image to publish and hit G to open the grid. Now look at the Publish Service you want to use and open it with the arrow on the right side. If you have more than one gallery, drag that image to the gallery you want to put it in. Click on that gallery and you'll see your image is at the top under "New Photos to Publish." At the top right you'll see a "Publish" button. Click on it.

Now go to the Gallery to which you published your photo, add the title and description, and do any other organizing steps you might want to do.

And just to underscore what I said above about your brand, make sure your gallery is set up professionally and linked to your other social media and to your email signature. Again the great thing about using SmugMug is that you can add to it to make it your website: Put in your bio and artist statement, a contact page, etc.

PRINTS

I definitely recommend that you take your best work and get large prints made, but I do not recommend that you print them yourself, except for "test prints."

Why not? Because to achieve a very high quality you would need to purchase equipment that is both cost and time prohibitive. I believe that both would be better spent on the other stages of the cycle, such as capturing and processing more images to build your catalog.

I know some will say that this violates the point of being in control of the process, and I have an answer for that. But you're not going to be happy with inexpensive prints from a desktop printer. And on the other extreme, I doubt you want to invest $2,000 – $5,000 (or much more) in a high-level printer and then take the time to master it, take care of its needs, etc.

My recommendation is to find a solid, reliable company that will give you great service and really understands the needs of photographers. That's easy: work with BayPhoto.com. I've known them for years and I know the CEO. They are dedicated to giving you what you want and are easy to work with online. See our resource page for their discount code.

Start by getting a set of 8 x 10s printed of your best work and go from there to larger sizes.

When you're ready for high-end custom prints, find someone in your area who produces really beautiful work and read their reviews. Tell them you want to come tour their lab or studio and

go through the printing cycle with them. In the end, you have to see the finished print in the light in which you'll be displaying it to know that you've gotten exactly what you want. They should have a test area where they can display your print in similar conditions to yours. Then you can dial in exactly what you desire.

In this case, the ideal work flow is: go with the images you want to print, export them from Lr as high quality, full-size JPEGs (or whatever format they specify), then put them on a separate drive that the printer service can plug into their computer and use to make final adjustments using their software. Once you have the prints exactly as you want them, be sure the printers send you or give you the digital files so you can import them into Lr for later use.

Now that you have prints, let's find the best ones and get them matted and framed. Just as in framing your image in the camera, matting and a frame give your print depth and make it stand out, and of course provide a great presentation for your photograph. My recommendation here is the same as finding a local printer: find someone who does great work with good reviews that you are comfortable working with. A great framer is another artist with whom you will collaborate, together making the final presentation of your photographs. I have used the same framer for years, and if you're in the San Francisco area (or are wiling to travel), you should too, they are simply the best: Richard Sumner Gallery in Palo Alto, CA.

The next stage of sharing is to properly display or hang your prints. Put them up where others will see them, placed to show them off well, not cluttered against other art and items.

(Think of your histogram – you want an even, aesthetic display of your art!) Also, don't stack them on top of each other; they get mushed together that way. Give them each their own clear linear space.

SHOWING YOUR WORK

My mantra for this stage is get your work out there! Get it seen by others and see how they respond. This gives you needed feedback as an artist. Photography is a communication medium, and as with all good communication, it needs to be two-way. The way to receive communication coming back is to show your work as widely as possible.

Here are some steps you can take:

A recommendation from Chase Jarvis, who is both an incredibly accomplished photographer and the CEO of CreativeLive (which provides online classes in a variety of creative fields), is to create a portfolio of your ten best photographs. Why ten? It's a good round number to represent your work. As you elevate your skills, switch out your top ten, even if it's a re-edit of your earlier images. It's a great first assignment to get together or newly make your portfolio and then keep constantly raising the bar of your top ten.

Follow my advice above and get those ten images printed in high quality and put them in a professional portfolio case, which you can buy online.

The best way to start showing your work is with family, friends, and groups that you have a connection or tie with already. Here are some suggested steps:

1. Once you have your online gallery together, send its link to a select list of friends and ask them for comments as feedback on your site (or to be sent to you directly if they have suggestions). You'll start collecting some great kudos that you can then add to a page on your gallery or have on hand for other steps that follow.

2. Once you've done this, if you need to make any changes based on the feedback, then address those. For example, it might have been suggested that you use a white background to show off your work. If you agree, then make that change.

3. Now send out your site to everyone you know! Don't overlook anyone, and tell them you'd love to hear back from them. This is important, since we all receive so much email – talk to them personally and ask them to respond and to share your link with others. (You don't get what you don't ask for, so always ask!)

4. Now send it off to any schools, associations, clubs, etc. you have ever been involved with. Try to find someone you know there to send it to, or look them up online and find their alumni coordinator, or whoever seems to handle that area. (Schools love to hear from alumni and art is especially popular.)

5. Leave no stone unturned; keep looking for past contacts and send them a link to your gallery with a personal note.

Let's get your work shown physically. There's nothing like having your work viewed with people looking at it and engaged with it. Here are some simple steps:

6. Look for venues to show your work. Following the same steps as above, make a list of nearby schools, galleries, clubs, coffeehouses, shops, libraries, etc. that you like and to which you have some sort of personal connection. Most public areas love to display art, and often they have a program in place with local artists – remember you have something that they need. Put a star (*) next to the ones you have the closest contact with (more stars are better).

7. Beginning with the one with the most *s, look up the person who might be in charge of showing art. Then pick up the phone and make the call. If it's a gallery, ask for the owner or curator. If you are calling a library, ask for whomever handles art displays. Tell them briefly who you are and that you would like to make an appointment to come by and show them your work for potential display.

8. Go to your appointment with your portfolio case in hand, including copies of your artist statement. Dress appropriately for the role – part of building your brand is looking like the photographer you want to be!

9. When you are in front of them, briefly tell them more about who you are, that you are a local photographer (plus any other connection such as being an alumnus of the school, or that you've been coming to this library since you were a tad, etc. – make a connection).

Without any hesitation, open up your portfolio and begin to show them your work, but let your art do the talking, don't chatter nervously, in fact let them ask you questions and answer briefly, keeping the attention on your work. You have not asked for anything yet, you are simply showing them your work.

10. When they are done reviewing your top ten works, they may ask about you showing there; if so, great, go with it. If they don't, tell them that you would like them to consider showing your work. Again, don't chatter, keep your work out there so they can see it. They will probably have some questions like, "Do you have these framed?" "How large are they?" Answer any questions and keep the conversation moving towards the "close" where they say "yes." They may need to ask the owner, manager etc., but even then, find out when you should check back with them. And before you leave, ask if they have any other questions.

11. Simply follow up moving forward. You will get some who are interested and some who aren't, just ignore those who aren't and keep asking and showing! You will get a "yes" and book your first show!

>> **Datebook section of the San Francisco Chronicle with my show promoted**

12. Once you have arranged an exhibit, do everything possible to make it a total success, which means you'll want a lot of people there. Here are some ways to make that happen:

 a. If possible, set a date for an "artist reception" which is your "meet and greet" when the show opens.

 b. Start an email campaign using a free email service like MailChimp, add everyone you know

from the list you compiled earlier, and be sure to add me to your list!

c. Get notices of your show and reception in your local newspapers; look for who handles the events calendar, send them all the data about your opening and show, and always include one of your photos in everything you send out. Do the same for online event notices.

d. Look for all possible ways to promote your show!

13. You should go for displaying your work as large as possible for the space, and within reason, as large as high quality prints can be made. If you've used raw files or at least large JPEGs, you should be fine with 16 x 20 or 11 x 14. Ideally, get these custom printed as I talked about earlier, or from Bay Photo. When you have the prints, look them over to be sure they came out well, and get any redone if there were any problems. Then have them professionally framed.

14. Sometimes whoever is doing the show will want to "hang" it and take care of the details, otherwise when you hang the show, place them aesthetically in the space so that people can walk around and see them easily at eye level. Place them linearly, not on top of each other. You can find tags at an art supply store to print your name, the name of the photo, its price, and where it was taken under it.

15. Do everything you can to make the opening attractive and conducive to looking at your art: Work with your host to have some food and drinks (wine or sodas, water, etc.) on hand and make the space look attractive.

16. Have copies of your artist statement and the price of your prints on a sheet so you can take orders right there. (It is a thrill to sell your photographs – it is the biggest compliment you can receive!)

TIPS FOR GETTING YOUR WORK OUT (AND EVEN GOING PRO!)

Don't ever be concerned about or shy about "self-promoting." The fact is that you are your own "Chief Marketing Officer," until you find someone as passionate about your work as you are. As you get rolling, hopefully you'll be able to team up with someone who will help you promote your work, but the "hat" will still probably be yours for a long time.

In the above steps to book a show, I didn't say to start by sending out emails – you have a much better chance of getting a "yes" by personal contact. But after you land one show, you can begin to leverage that and use it in emails – especially to more distant venues.

It's important to know that you are marketing your work and yourself! Think of the great artists who have become popular (in their lifetime, which eliminates Van Gogh and many others) and you'll see that each of them created an image, a "brand," that was a key part of promoting their work. Always go for personal

contact as much as you can, knowing that you are marketing yourself and your work.

Just as you create a photograph, you create your own opportunities: Look for ways to pitch your work in your area. Is there a local magazine? Go see the editor and pitch them on an idea for your work. Think of an idea that interests you, such as creating a photo essay about your area, with landscape shots of unusual images that people might not be expecting. My polo shot on page 48 is an example.

When you get to a point where you are considering going pro, the best advice I can give you is to find a good working photographer (in your genre and whose work you admire) in your area and reach to them about apprenticing with them. Getting real-time studio experience is the very best way to learn the trade. Pick up as much as you can by jumping into any task needed and learning the ropes. Many of my past apprentices have gone on to establish their own very successful careers.

No matter how you go about it, get your work shared in a professional manner and continue to look for new ways to get it out there!

ONE LAST WORD OF ADVICE

"WHATEVER YOU DO, YOU NEED COURAGE. WHATEVER COURSE YOU DECIDE UPON, THERE WILL ALWAYS BE SOMEONE TO TELL YOU THAT YOU ARE WRONG."

– RALPH WALDO EMERSON

As an artist, you should be aware that there are "vampires" out there, meaning people who try to rob you of your life and what you have created. They may sometimes act like your best friend, with "creative criticism," but if this results in your slowing down or being discouraged, recognize what you have encountered! You can ignore the naysayers and keep them away from you, and you and your art will be better off for it. There's much more to this, which I'm happy to discuss.

CRASH COURSE/SUMMARY

1. Visualization includes you as a photographer and your "brand."

2. Focus on your genre and develop your style.

3. Put together a professional image starting with your bio and artist statement.

4. Only publish your Lr processed work on social media or on any channels you use.

5. Use Lr Mobile for social media.

6. Create an online gallery and add your best photos directly from Lr.

7. Get your prints made professionally.

8. Take your best and have them professionally matted and framed.

9. Hang them well, cleanly and in a linear arrangement.

10. Get your work out there! Get into shows!

11. Make a portfolio with your top ten photos.

12. Get your site out to family and friends.

13. Then keep sending it to as wide a circle as you can. 14. Look for venues to show your work.

14. Go see decision-makers at venues and pitch a showing of your work.

15. Book a show, and make it successful by promoting it well.

16. Don't be concerned about "self-promoting" – you are your own "Chief Marketing Officer!" You are marketing your art and yourself.

17. Look for a local photographer to apprentice with.

18. Avoid naysayers and vampires.

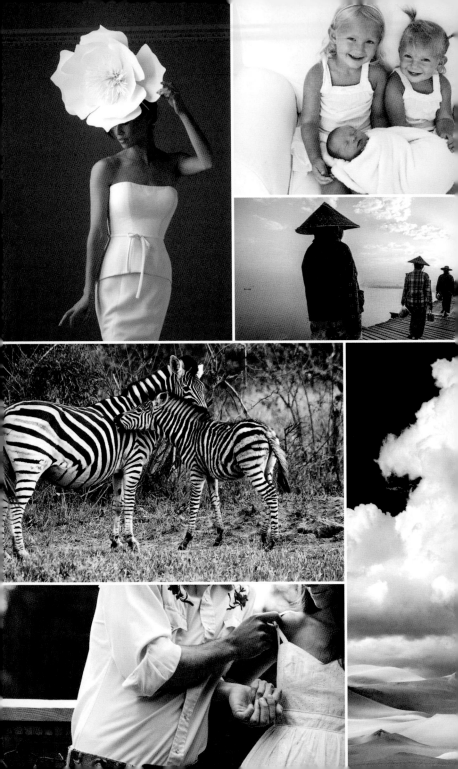

CHAPTER 7
TIPS FOR MASTERING THE GENRES OF PHOTOGRAPHY

>> Top row: Bambi Cantrell, Lena Hyde, Robert Holmes; second row: Marc Silber, Huntington Witherill, Eric Johnson; bottom row: Anna Kuperberg, John Todd.

"CREATIVITY IS INVENTING, EXPERIMENTING, GROWING, TAKING RISKS, BREAKING RULES, MAKING MISTAKES, AND HAVING FUN."

– MARY LOU COOK, ACTOR

In the last chapter, I advised you to work out your strong suit as a photographer and really zero in on it as your brand. This is what you will be known for and the position you want to own in people's minds when they think of you.

Having said that, I don't want to you to feel limited in what you can photograph or what genres that you can weave in and out of as you choose and wish to explore.

For example, Annie Leibovitz is known as a celebrity photographer, but has also developed her style of landscape photography and everyday life images. She carries a camera with her all the time and seems to be photographing what is going on around her constantly – ranging from the deep losses she has encountered to light moments with her family.

As a serious photographer, you are going to be thrown into a wide range of opportunities to capture life and to broaden your own library. In this section of the book, we'll cover some key tips from top photographers in a variety of genres. I'm hoping that you will digest each and go out and try them on for size. They also serve as handy references you can pull out of your camera bag and turn to quickly when you suddenly find yourself in one of these situations!

I'm going to draw from a collection of the hundreds of interviews I have conducted with professional photographers covering a wide range of genres. They speak from deep experience as pros who have to show up with "the goods" to deliver to their editors and clients. But please don't expect a full course meal in each area; I hope the following will serve to point out some of the ingredients and whet your appetite for more.

GENERAL TIPS

Here are some common tips that will serve you well as a checklist to pack in your camera bag.

Know before you go: Research, research, research as an aid to your visualization. Before you go out on a shoot of any kind, spend some quality time doing your homework and taking notes that you can bring with you on the shoot. Let's say you're going to be shooting a local high school football team: Google to see what other images have already been taken. Look over the layout of the stadium, and note some of the best places from which to shoot.

Look up the coach and players to see what interests you about them, and note how you might want to capture them.

Search for classic images that have been captured in this genre. In this example, look for some of the classic football photographs for your mental library.

Check on the weather for the day of the shoot and also sunrise and sunset to know when the golden hours are and what type of light you'll be working with (we'll talk more about this in a moment). You might find out that rain is likely – which dictates your equipment choices.

As you gather this information, begin to visualize the shoot and the images that you want to bring back.

If it's practical, go to the venue ahead of time to walk around and tie together the real-time visual layout with what you have learned in your research.

A major part of knowing before you go is to decide what you are intending to capture. Have a well-defined purpose in your mind for what you want at the end of the shoot, which will carry you through the entire session.

Nail your equipment down: Always, always, always check your equipment with an equipment checklist. (See Appendix 2 for a guide that you can customize for yourself.)

I had the opportunity to meet up with my fellow San Francisco Art Institute alumna Annie Leibovitz. Our film team was with us and I was mainly focused on capturing video, but I wanted to get stills too, so I brought my Nikon along. As we were readying for Annie to come out to speak, I was asked for camera advice, which I'm always happy to supply.

Now it was my turn to get ready: camera, card, battery; no battery – no problem, I had another in my bag in my car, but time was getting tight. Jogged out to my Land Rover and opened my trusty case – not another battery in sight! Then I remembered – I had charged them, and there they sat in my studio!

Later, I borrowed a friend's Canon that I was not familiar with at all, yet I was still able to get a fantastic shot of Annie, but after

that I always had equipment checks on my pre-shoot checklist, no matter what!

Your pre-shoot research above will add to your equipment checklist. If you see rain is likely, add an umbrella, parkas, and ideally a GoPro to your checklist. If you know available light could be short, add reflectors and speed lights – you get the point.

To get instant inspiration, pull up some favorite examples of the genre you're shooting on your smart phone. Look at the composition, lighting, and other factors to get your visualization juices flowing, right on the spot.

You will find that even though the following tips are for a specific genre, that they will "cross-pollinate" with other genres too, which is another good reason to be familiar with each and try them out.

LANDSCAPE PHOTOGRAPHY

The weather and sky can play a huge part in your landscapes. Look over landscapes that you love – paintings or photographs – and you'll frequently see dramatic clouds, contrary to the song, "Home on the Range" ("and the skies are not cloudy all day").

Clouds add depth and dimension and have a wonderful way of capturing, filtering, and changing light, often with consequent brilliant colors. Some of them even seem to have personalities, and capturing them qualifies as "portraits!"

This is a chart of the different cloud types and where you can see them in the sky. The most photogenic and my favorite are the low, puffy cumulus clouds and of course their big brothers, the cumulonimbus or thunderheads.

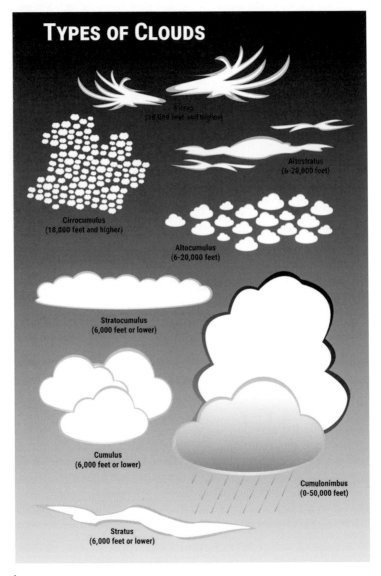

How to be sure you've got "weather"? Keep an eye out on the weather reports. There are even apps that will alert you to severe weather and a free service that will send you email alerts, including the types of clouds expected that day. I recommend spending some time learning about different types of clouds and what causes them so you can predict when it will be a good time to go grab your camera.

We've talked about the golden hours, the hour periods around sunrise and sunset when you have beautiful light – that's when you want to be out shooting! Do your shopping, eating, and napping in between. And you'll find there's an app that will alert you to these hours, too!

Of course, you can't always be shooting at these ideal times, so given the hours you have to shoot, look for the best light and position, angles, framing, etc., as we've covered.

>> *Each Year We Pray – Kansas, USA, Camille Seaman*

Camille Seaman, a photographer of stunning landscapes, gave me these tips for capturing her images:

1. She's always thinking first about the quality of the light. Then if the quality of light is there, she is looking for the "scene", which is whatever it is that she is photographing.

 (As we've previously discussed, she recommends looking at the light in old paintings by artists such as Vermeer, Rembrandt, Caravaggio, and Michelangelo, who use natural light.)

2. She also said when she went to Antarctica she started to photograph everything she saw as if it were a person, even icebergs, and coupled with her awareness of light, she said, "It was magic!"

3. Her tip for composition: "Think of everything as shapes. You're arranging the shapes in such a way to interact and to activate space, to push things forward and pull things back, to draw your eye here or guide your eye there. When you understand that, and you do it that way, composition becomes like a ballet, really it becomes choreography."

Putting her advice to work:

Look for "portraits" in your landscapes: The rock face, tree, or clouds – make portraits of them as you would of a person.

Look at the shapes within your frame. Take various shots moving about – back and forth, up and down, to the sides – until you find the arrangement of shapes and lines that lead the eye to what you want your viewer to focus on, with the portrait analogy: the "eyes" of the subject of your composition.

PORTRAITS

» **Bambi Cantrell**

Bambi Cantrell, a multi-award-winning, highly sought-after photographer, is a master of portraiture. She explained her step-by-step approach to me:

1. Find the prettiest light source, such as a light from a window, or in an outdoor environment – which is less intimidating than having a lot of lights and equipment. She'll sometimes use a reflector made from a sheet of reflective insulation from Home Depot, cut to the size of a window with tape on the edges.

 A. Look for "catch lights", which are the small reflections in the eyes from the light source. To look natural, these should be in the upper part of the eyes (such as at 2 or 11 o'clock); when they are low in the eyes, they look unnatural.

 B. Be aware of shadow areas on the face, are they above the nose or below it? See if they look natural.

Adjust these both by moving the reflector and by having your subject move until you see what you want.

2. Find a location that is simple and distraction-free. "It's not about the location, it's about the face."

3. The most important element is having your subject forget that the camera is there. Take a personal interest in them; look into their eyes and talk to them. Help them forget about the camera and pull great expression from them. As she says, "Expression beats perfection!"

4. Her secret to getting the expression is to play around and ask them all kinds of questions, such as "What makes you happy? What do you do for a living, what's your favorite color?" She pays very close attention to the expressions on their face as they answer, looking for small changes in their eyes and mouth that show their expression and emotion. She makes the point, "The art of communication is the real key to success."

5. She shoots with shallow depth of field, with her aperture set at 2.0 or 2.8 since her images are intimate and about the person's face, not the whole environment.

6. To get that intimacy, her favorite lenses are 70–200mm, 2.8, 135mm, 2.0 and the 50mm, 1.2.

7. If someone is too stiff or you need to adjust the light, move them, but show them by acting as a mirror image, facing them and using your body to demonstrate where you want them to move.

8. Have a good time: "I don't take myself seriously...if you start taking yourself too seriously you lose that magical moment that happens in people."

9. Use your camera angles:

 A. When working with a mature woman, shoot from a higher camera angle looking down on her to avoid seeing saggy skin under her neck. This draws attention to the upper part of the face and not the jawline. Also, with any subject

have her drop her chin and look up with her
eyes, which makes the eyes appear larger.

B. With a man, use a low camera angle looking up
at him to make him appear more powerful,
stronger, and taller.

C. When working with a heavier subject, use a
higher camera angle and have them lean forward
with their chest.

Practice using these key points, moving your subject (and if
needed, the reflector) and observing how they affect your subject
and how to make adjustments to get the look you want.

ENVIRONMENTAL PORTRAITS

There are a few ways you can go about capturing a meaningful
environmental portrait. Again, pull up on your phone some
images you admire, such as portraits by Arnold Newman, to get
some ideas and inspiration.

The most basic way is to capture the person in the environment
that they are most known for or comfortable in: a pianist at his
piano, a chemist in his lab, a writer at her computer, etc. Look
for various angles and ways to capture and use the space to tell
a story.

>> **Chris Burkard, capturing the world one frame at a time.
Photo by Eric Johnson**

Chris Burkard is an outstanding outdoor and action photographer
with huge accomplishments. He told me, "Sometimes the simple
moments are the best. Whether you're out camping somewhere
or you're shooting someone reading by their headlights, any
simple little thing that's going to spark an interest or spark a
meaning in someone, that's what I aim for."

He says it's like building a story. He always looks for those
"moments in between," for example, someone getting ready
when they don't know you're shooting. Look for your subject's
reaction to the scene. "Pull back and see, what are they thinking,
what are they experiencing?" And aim to capture that emotion.
"When you stop and think about what's going to be the most

significant thing, a lot of times it's not necessarily what you're seeing but what someone else might be seeing."

Think of your shoot in terms of telling a story about your subject, shooting them from various angles and positions. They may be posed for the shot, but keep shooting to get the "moments in between" as Chris said, showing what they are looking at or are interested in.

CHILDREN'S PHOTOGRAPHY

» **Lena Hyde**

I gathered some fantastic tips from Lena Hyde, whose work has appeared in publications such as USA Today, People,and LIFE. She's an exceptional photographer of children:

1. Before she gets to the shoot, she talks to the parents to find out about the children and their personalities, who's shy, what are they "into", etc. She asks when the light is brightest in the home and when their children are the happiest (usually the morning) to plan the shoot time.

2. She keeps her bag light to avoid bringing in a lot of equipment, which can cause children to be afraid. Her go-to lenses are 24-70mm, 2.8, and she loves the 70-200mm, 2.8.

3. She shoots off tripod and with no lights or reflectors so she can easily follow the child, and to make it easy for them to move around and be comfortable.

4. Her first step is to look around the house for the best light and what looks good visually (without clutter and with good light and appropriate décor).

5. She'll move the children near the light sources as needed to get good directional sunlight. She'll sometimes shoot in a white room to reflect and even wear a white shirt to reflect.

6. With newborns, get the parents involved to get the emotions between them.

7. She gets to know the child, and to make them more comfortable she might pull out finger puppets (giving them voices) or a squeaky toy.

8. She recommends shooting from many angles and getting a lot of shots. (Remember to get down to the child's level too, even sitting on the floor with them or crouching down low.)

9. And finally, have a good time with the children, and make it a fun experience. (Sounds familiar!)

TRAVEL PHOTOGRAPHY

I always photograph extensively in my travels. This is a great opportunity to build your library of images. Here are some key tips from Bob Holmes, who was a National Geographic photographer and has won a slew of awards for his travel photography:

1. Travel light. You want to be able to go out with a small bag with all your day's gear in it, plus some handy items that might be needed: snacks, or possibly a parka. Don't get bogged down with excess equipment!

2. He likes to use a wide-angle lens like a 28-35mm, but gets close to the subject to make them feel part of the scene.

3. Prepare yourself to see and capture images. This comes from what we've talked about previously: know your equipment backwards and forwards and study artists.

4. Be fully involved in your subject. Make time to shoot on your own, fully being a photographer, not a tourist, a shopper, or just an observer. Get in the "zone" and

look deeply at the surroundings before you even look through the camera. He calls this being "consciously intuitive."

5. When he shoots, he looks for a "punctuation point." It is that extra little thing, which could be a person's gesture or their motion, and is taken at the "Decisive Moment."

» **An example of a "punctuation point" Havana, Cuba, Robert Holmes.**

6. He also looks for strong colors.

7. He looks for geometry in his composition, such as diagonal lines, which can give the image vitality. He often uses symmetry to give interest. (See page 219 for his example of this.)

8. Look for ways to inject excitement and interest in the photograph with these points. Wait until you get it, it may take time for things to all line up.

9. Change your viewpoint to best convey the story you're telling and the message you're trying to get across. For example, shoot a scene looking down rather than straight forward. (See his example on page 102.)

I'd add:

10. Go with a shot list of images that you want to bring back home, and make it a game to find each, like a scavenger hunt.

11. Review your work daily* so you can see how the story of your trip is coming along. Self-critique if you need to make improvements or to see areas you need to fill in.

*Look at your images on a computer or a tablet, or bring connectors to plug your camera into a TV in your hotel to see them larger than just the back of your camera. Such viewing is also fun for your traveling companions.

SPORTS PHOTOGRAPHY

Whether it's your kid's baseball game or your favorite team, sports are always a great opportunity to capture some stand-out images.

Here are some tips from sports photographer John Todd, whose work has appeared in USA Today, Sports Illustrated, and ESPN the Magazine:

1. His approach is "simple and clean." "How can I make my subject pop out of the frame?"

2. He always works out what the story is that he's going for before he goes out and shoots. Then he'll be able to go after those shots.

3. He said the key is to "Get low, get high." For example, with soccer or a field sport, try to get as low as you can.

4. Then get high: go up in the stands, which helps you clean up your background and gives you perspective.

» **Shooting up high, JohnTodd.com, see his image on page 100 for shooting low**

5. He shoots with a 70-200mm and has trained himself to be able to get the camera in place and shoot one handed for fast reaction time, which is essential to capture the "Decisive Moment" and emotions.

6. Just as in playing a sport, in photographing sports, practice is essential. He'll go in his backyard and practice quick focusing. "That's really the key to sports photography!"

I'd add:

7. Look for other moments that help tell your story, not just during the action on the field. For example, with my polo shoot, I captured a pony in her stall as well as a few pairs of boots and other items surrounding the main action.

» **Polo boots, Atherton, CA, Marc Silber**

» **Horse in her stall, Atherton, CA, Marc Silber**

ANIMAL PHOTOGRAPHY

It's exciting to capture animals and to tell a story, whether it's about your own pet or out in the wild.

Florian Schulz, an outstanding wildlife photographer, gave me these tips:

1. Before he starts to photograph, he studies the animals to understand how they use the landscape. Look for tracks and game trails for clues to this. He wants to incorporate the animal in the scene, in their environment

2. After you have this background information, what comes next is patience. People often underestimate how long it takes to get really good images. He often visits a place five to ten times before he finally captures what he's looking for.

» **Florian Schulz captured the same bear with three different focal lengths: 200, 400 and 600mm.**

3. He says his best advice technically is to use all the lenses you have in your bag. Shoot the same scene with your widest lens and also with a telephoto. You might zoom in to get a tight portrait of the animal, but then step back with your wide angle to get the whole scene. He says that by doing this you'll learn about perspective and about how the impression changes with your different lenses, and you'll get so many more different results to work with.

I also talked to David Smith, a multiple-award-winning South African photographer, who gave me these tips:

4. Don't always put your animal in the center of the frame: Focus on them, hold your focus, and then move them within the frame. Use your grid view in your camera to place them on a point of thirds, which has a really strong dynamic pull to the eye. You might have the animal looking into the frame or looking across the frame. If the animal is looking to the left, leave more space on the left for it to look into, and the same of course on the

>> **Leopard, Okavango Delta Botswana, David Smith**

right. If the animal is looking up, put them low in the frame looking up at something. (See his image with points of thirds on page 94)

5. The above helps to tell a story, adding interest and intrigue. Is that leopard gazing at something, or is it going to start hunting something which is just out of the frame?

6. Look at your background, which can make or break the photograph. The foreground can be perfect, but if the background is all jumbled, it's not going to work.

7. Always focus on the animal's eyes, hold the focus, then recompose and place it where you want it to be.

8. Check from corner to corner of the frame and make sure you have nothing distracting in it.

9. With long (telephoto) lenses, always use a tripod, but if that's not possible, bring along a beanbag that you can put on a seat or other surface to support the lens. He also uses a tripod head that you can clamp onto a rail in the vehicle, which you can easily pan to follow animals in motion.

WEDDING AND EVENT PHOTOGRAPHY

As I mentioned in Chapter 2, you should approach weddings and events with a shot list so you don't leave out any important people or moments. Wedding Photographer Chris Kight gave me these tips for full coverage of a wedding: Write a list of every single key person who will be in the wedding, including all

the relatives on both sides. Don't leave out the great-aunt, for example. On this list, include all the "obligatory" shots.

Tip: You can google "Wedding Shot List" and you'll see some that you can use as a template and modify for your specific wedding. The shot list will also serve as a time line guide. For example, if you're covering the rehearsal and the rehearsal dinner, you'll want to get all those shots, then the next day, you'll shoot the bride and bridesmaids getting ready and the groom and groomsmen, etc., on through the day.

Chris says, at first, concentrate on completing your shot list; carry the list in your bag and check off your shots methodically. However, don't be so dedicated to the list that you miss the candids! Be alert for those "moments in between" that you may never have another opportunity to capture.

Once you have your shot list completed, then fully make the switch over to catching those candid moments and the ambience of the venue.

Bambi Cantrell, whom we heard from earlier about portraits, is also a fantastic wedding photographer, so review her tips as well, as many will apply here too.

Anna Kuperberg, a very talented wedding and family (and dog) photographer, also gave me this important advice, especially for the candid stage of your shoot:

 1. You want to have a clear head, and stop and observe

and be open to things that aren't the clichés or the expected things.

2. Don't just go for the flat, two-dimensional shots: "Go over there and kiss." Instead, look at how the people really interact with each other. Allow yourself to see these moments.

» **Anna Kuperberg**

Examples are the way they hold hands, or that their feet are touching or that one is leaning on the other person, the way they look into each other's eyes, a knowing look, etc. This is true even if you are directing the shots; you still have to be tuned in to these points.

>> **"Look for how people really interact with each other,"**
Anna Kuperberg

With other events, whether family or groups or business, follow these same steps: Compile a complete shot list so you have full coverage, but then get those candid, non-cliché moments and you'll have truly captured not just the event itself, but its spirit and the spirit of the people – which is what it's about at the end of the day!

STILL LIFE PHOTOGRAPHY

Still life photography is a lot like landscape photography, but on a smaller scale, thus you can have more control over the object's position and lighting. But then again, it's like taking a portrait of the object, so tips from these two areas will serve you well.

Again, the best advice I can give you is to find examples of still life that you admire (such as Vermeer, Edward Weston, etc.) and to simply work to create that look for yourself until you find your own "voice."

Hunter Freeman, who has done product shots for Apple and a host of big brands, gave me this advice:

1. He loves natural light. Even if he's lighting the scene, he wants it to look like natural light so people looking at it think you had nice light that day, not that you lit it artificially.

2. But there's also an approach to lighting it in an interesting way that doesn't have anything to do with natural, available light – which can look fantastic! He said that's how lighting techniques have been developed over the years, by "trying wacky things."

3. What this comes down to is experimenting, which is part of the fun. Look out for unusual or strange light that is interesting, and use that for your still life.

4. For his formal product shoots, he'll get a layout from the client of the end shot they want, which could just be a pencil sketch. His goal is to create an ad with an image that draws people in. From this rough layout, he'll make a list of the details he'll need to have in place, which could be location, talent, or even weather.

5. To create a photograph that draws people in or is compelling, he says he has to find that thing that is interesting and amazing about it, and let it be revealed.

» **Find what's interesting, Hunter Freeman**

6. Drilling down further on this, he said he looks for qualities in the subject, for example, how does the light interact with with an object, or how is it used? What's going to bring out the qualities of that object?

CRASH COURSE/SUMMARY

1. Even though you may be focused on "your genre" be willing to play with and experiment with many others. (This experience will help you hone your craft even more.)

2. Know before you go: Do your homework on the type of shoot you'll be doing. Use your smartphone at the scene to refer back to examples you've found.

3. Nail your equipment down with a checklist.

4. Know the weather – clouds are very photogenic, for example, and know the golden hours (there are apps for these two).

5. **Landscapes:**

 A. Look for the quality of the light first.

 B. You can take portraits of natural objects too!

 C. Look for shapes and how you can best arrange them to tell your story, like choreography.

6. **Portraits:**

 A. Look for the prettiest light.

 B. Place your subject to utilize that light naturally (watch the catch lights and shadows).

 C. It's about the face, not the location, so use a shallow depth of field.

 D. Help your subject forget about the camera – keep it fun and engage them in communication.

 E. Use the angles that help your subject look their best.

7. **Environmental portraits** are different, since you are also including the subject's surroundings of which they are a part.

 A. Look for simple candid moments.

 B. Capture what they are looking at or thinking about.

 C. Capture the "moments in between" action or events.

8. **Children's Photography** – make it fun for them!

 A. Find out when they are happiest and arrange the shoot accordingly (also for the best light).

 B. Keep equipment simple.

 C. Watch for what looks good visually, simple décor and good light.

 D. With babies and newborns, have the parents involved.

 E. Use finger puppets and other props to engage children and help them forget the camera.

 F. Shoot from lots of angles; remember to get down low with children.

9. **Travel Photography:**

 A. Again, travel light with a small bag, but include needed items.

 B. Be prepared to capture images by knowing your equipment and studying artists.

 C. You might use a wide angle, but get close to the subject to make them feel a part of the scene.

D. Go out on your own and get in the "zone!"

E. Look for gestures and "punctuation points" that add interest.

F. Look for geometry in the scene, including diagonal lines and symmetry, other lines, and geometrical items.

G. Wait for the shot!

10. Sports:

A. Keep it simple and clean to make the subject pop out of the frame!

B. Work out the story that you're going for.

C. Shoot low, Shoot high!

D. Train yourself to set up for a shot and focus rapidly. Practice this so you don't miss the decisive moment.

11. Animal photography:

A. Study how the animals use the landscape.

B. Be patient and willing to go back again and again.

C. Use all the lenses you have: Take the same shot using wide and telephoto lenses, for example

D. Frame shots using the rule of thirds; if an animal is looking to the left, leave space in the frame on the left, for example.

E. Your background can make or break your photo.

F. Always focus on the animal's eyes; hold focus and recompose if needed.

G. With long lenses, use a tripod, beanbag, or other support.

12. **Weddings and events:**

A. Create a detailed shot list and nail it!

B. But also get your candids.

C. Go beyond clichés by seeing how your subjects really interact with each other.

D. These same points will work for other events as well.

13. **Still lifes are a lot like small landscapes, but also like portraits.**

A. Use natural light, but don't be afraid to experiment with unusual light that is interesting.

B. Product shots start with a layout or pencil drawing, then work out your details.

C. Find what is interesting or compelling about the objects and reveal it! This could be how the light interacts with them or how it's used.

CHAPTER 8

MASTERING THE WHOLE CYCLE OF PHOTOGRAPHY: WHERE TO GO FROM HERE

**"I AM ALWAYS DOING THAT WHICH I CANNOT DO,
IN ORDER THAT I MAY LEARN HOW TO DO IT."**

– PABLO PICASSO

We've covered the whole cycle of photography: visualization →
equipment → capture → processing → sharing to get your work
out to the world. And we covered tips from some key genres,
hopefully with just enough about each to get you started and
whet your appetite to learn more.

The cycle of photography isn't a flat road. By following each
stage to the next, you are climbing an upward spiral, as you
have no doubt found. For example, by improving your skills with
processing, the next time you go out and shoot, you have a better
ability to visualize the final image. The same is true when you dig
into your camera's Field Guide or manual: you learn new features
that help you broaden your ability to capture images.

Now that we have covered the full cycle, I'm going to give
you some of my tips that I've gathered along the way, to keep
advancing your photography skills.

DO WHAT YOU CANNOT DO

It can be easy to hit a plateau by making images that are easy or
comfortable for you – I know, I've done it thousands of times!
Some examples of cliché images are taking landscapes with pat
framing through the trees, or a certain pose you've used over and
over – you probably have your own list.

If you find yourself going after a cliché image (even if only a personal cliché), break out by following Chase Jarvis' advice of, "...trying to do something that is unusual. How can I put a little twist on it, or as we say when we're on set, 'how can we turn this one on its head?' I look for ways to make it different, those are the little things that separate it from making it an interesting photograph to a great photograph. "

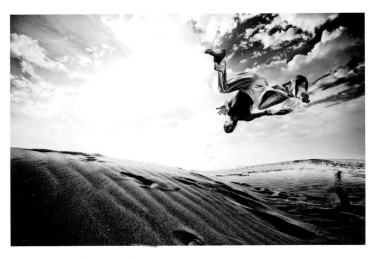

» **Jumper, Chase Jarvis**

But how? By pushing yourself to try new approaches and look for new angles, different lighting, a different way of visualizing. For example, every time you see a beautiful sunset, you shoot into it, capturing the glow of the sun going down (which gets you a string of "likes," encouraging you to keep shooting them). But instead, turn the other way and capture that gorgeous glow hitting an object or a person. The obvious can be so tempting that it's hard to let it go. Okay then, capture it that way, but then go on to "turn it on its head." Then look at your results, and learn how to do it better, as Picasso said.

That being said, you may also find that there is a certain type of image that you just can't help but capture. Then go for it, and make it an obsession and a passion and let the world see it as a series. Example: Richard Avedon loved to make simple portraits against a grey or white backdrop (which later became known as the "Apple" look – "great artist steal" as Steve Jobs quoted). If you have a passion like this, make those images, but push yourself to learn something new that you haven't tried before.

NON-STOP OBSESSION WITH LEARNING YOUR CRAFT

Don't think that photography is about the latest and greatest release. I recently acquired a mint condition Hasselblad 501c – a film camera that has been the choice of some of the greats of photography, including Steve McCurry and Chase Jarvis, plus other artists such as George Harrison and Brad Pitt. It was also the camera used by NASA on the moon.

This piece of equipment is an aesthetic and mechanical marvel. It came with its original manual, which I eagerly consumed with joy, reacquiring some of my film chops.

Along with the camera, I picked up a Luna Pro light meter, also accompanied by its original manual from about 1970. I hate to admit that I've been digital so long that I needed a refresher on the use of an exposure meter and so sat down for a full study of its manual. To my surprise, I clarified some questions I had about light by reading the manual. Needless to say, this has elevated my understanding of photography in general; anything that helps you to see light and understand it will advance your photography. There is a real joy to holding a device in your hand that is elegantly made for a single purpose. It doesn't take pictures, but it tells you what you need to know about the light you're looking at. I recommend that if you've never used a light meter, get one (you can find a good but inexpensive used one online), then carry it around and spot light readings on your next walk. This will help you tune up your perception of light. (There are some apps, too, but test their results against your camera's readings – I still prefer an actual meter.)

The Luna Pro even has a dial for "Zone system." This system divides luminance (relative brightness) of a scene into 10 Zones: Zone I is shadow with no detail, Zone V is middle grey, and I is pure white. You can easily correlate this to what we've gone over with the histogram to see that it's another way of evaluating light. A change of one zone corresponds to one f-stop. Keeping it real and simple, these tools can help you learn to perceive small differences in light.

BOOKS AND NOTEBOOKS

If you're like me, you spend too much time on a computer, so make time to go analog by compiling a reference library and keeping it handy. In my studio, I have a library of all my go-to books, ranging from the classics of photography to the newest Adobe Manuals for Creative Cloud. I also have several photography and film dictionaries (very important), some vintage photography books, and a whole section on filmmaking. I also keep all my Field Guides and hard copies of manuals (in addition to keeping them on the app I developed called Zither, which you can download for free on iTunes – see our resource page).

Another type of book that I keep on hand is artist's work – their photography and art. By now you should know why. I find great pleasure in sitting down at the end of the week and simply looking though one of these to get a new perspective on what they created and how they approached their craft. I find this is far more satisfying than just looking at their work online: The look of the book, its design, the way it is printed, the sequences of images, and the feel of the paper all add up to a visceral experience that is second only to seeing the original art. I invite you to do this often, in fact splurge on it!

These should all be easily accessible, not stuffed away in a box or closet, and referred to often.

Make a point to learn at least one new thing about photography every day and add that to your tool kit. As an aid to this, I keep a small (about 7"x 8") binder with A–Z tabs and jot down references so I can easily find them later. For example, what I

learned about the exposure meter I would note under L for light meter: "Reading Zone system, Luna Pro page 27." Believe me, it really helps to save this info, especially for obscure settings and things that required a lot of research.

I love notebooks, which have been a tradition with photographers and artists for ages, famously including Ernest Hemingway, Picasso, and Edward Weston's "Daybooks." In our more and more computer-centric lives, it's vital to keep touch with reality through paper, pen and pencil.

I have a whole host of notebooks for different uses in addition to my reference binder. I use the simple "composition notebooks" that you can buy in stationary stores for $1.99.

I have one dedicated to making sketches and notes as I'm studying; if you were to pick it up, you'd swear it was the work of some mad scientist on some antigravity formula, when in fact it was a sketch of a lens! Drawing things out as you study is a

great way to make sure you really grasp them and can put to use what you've just read.

I also keep a daily journal of discoveries, epiphanies, flashes of inspiration, plans, and whatever else comes to mind that day. I find that writing these down helps me to clarify, focus, and deepen my thoughts. These are not meant to be read by anyone but me, but I learn a lot by keeping them and occasionally looking back to see what I have previously discovered as well as what obstacles I have run into before that I might now have overcome and to keep myself on track.

ONLINE REFERENCES

Additionally, I make full use of Google, especially for hard to find words: You can query Google by typing "define_____", or "what is_____"; you'll get one definition at the top of the results, which often is all you need, if not, look down the page. If you're querying an exact phrase, put it in "quotes" to keep it focused.

And of course there is YouTube, where my show *Advancing Your Photography* lives, and I'm hoping you will take full advantage of the hundreds of videos I have produced. You'll also find a whole world of videos on every aspect of photography. Be selective: as with all things, I tend to stick with "name brands," so if I have a question about an Adobe product, I tend to watch their videos first. I would warn against poorly made videos, such as low quality audio or the instructor who spends a lot of time talking off point, or other signs that you should move on to a more reliable source. Lynda.com is handy for bites of data and CreativeLive for a deeper dive, they are both amazing resources. Be sure to check out Serge Ramelli to continually advance your Lightroom skills – he knows it inside out.

A handy way to keep track of what you find online (in addition to your binder) is to create notebooks in Evernote, a virtual tool for storing what you come across.

LEARNING FROM OTHER PHOTOGRAPHERS

If you've seen my show *Advancing Your Photography (AYP)*, you know I like to ask a lot of questions and really listen and learn. When you see me off camera, you'll see I do the same. One of my keys to success over the years has been to find people who have excelled in their field and ask them what made them successful and what worked for them and to take notes (in yet another notebook). Then I review my notes and write an action plan for implementing what made sense to me. There is another side benefit: Those who do this with you will benefit by having someone listen and help them articulate what they know (I'll talk about this more in a moment).

I believe as simple as this action is, it is one of the biggest "secrets" to success in any field. If you observe, you can see why this gem stays hidden: some feel too shy to ask, thinking they might be thought less of for being "ignorant." Another way of avoiding this is to spend one's time talking when one should be listening, again trying not to appear "stupid." But by approaching those who have mastered their craft with an open heart, they will in turn open to you the treasures of the world.

My secret on AYP is that I'm asking questions about what I want to know. For example, back in 2009 when I interviewed Joseph Holmes (a fantastic Landscape photographer), I was still fuzzy about using a histogram, so I asked him to explain it and show me at the same time. The result: The first clear demonstration of its use I'd ever had, which you can watch too.

THE BEST WAY TO LEARN IS TO TEACH

Having done extensive backpacking on my own and then having gone through several mountaineering courses and finally an instructor's course, I first became an instructor when I was 19. I learned that it was one thing to know skills myself for my own use, but when it came to teaching others, I had to have total certainty.

Since then, I have always seemed to wind up in a teaching role. So it was natural for me to teach photography through workshops, then with AYP, and now with the AYP Book. I have found that there's no faster way to find holes in my understanding than by preparing to teach someone else. Nomenclature (vocabulary of a subject) that I had taken for

granted suddenly jumped out at me, waving a flag – "why is it called that?" As a result, I would dive in, look it up, and clarify my understanding. Only then could I teach someone else.

But then I discovered something quite startling: When I taught someone else, my understanding of that subject went up through the roof! I noticed this with surprise, and then experiencing it consistently I understood that it was part of the joy of teaching: It turned out to be a two-way benefit.

I'm telling you this because you have in your hands a powerfully concise and codified approach to photography. Even if you're new to the subject, you may be amazed to find that you now know more than those who have been photographing for years "by the seat of their pants." They've managed to get some good results, but may never have known about the cycle of photography or its parts. Chances are they have plateaued in their skills, and you can help them advance by passing along what you've learned in this book.

COMPOSITION TIPS: LEARN THE LANGUAGE OF GEOMETRY

» **Havana, Cuba, Robert Holmes**

"THE GREATEST JOY FOR ME IS GEOMETRY, THAT MEANS A STRUCTURE...IT'S A SENSUOUS PLEASURE, AN INTELLECTUAL PLEASURE, AT THE SAME TIME TO HAVE EVERYTHING IN THE RIGHT PLACE. IT'S A RECOGNITION OF AN ORDER WHICH IS IN FRONT OF YOU."

– HENRI CARTIER-BRESSON.

When you look over Cartier-Bresson's images, you'll see he takes advantage of capturing the geometry of the decisive moment, a key ingredient in making his work so captivating. In the last chapter I advised that you spend time learning about clouds, now do the same with geometry.

Solid geometry deals with three-dimensional objects and lines that we see around us such as circles, spirals, cubes, etc. The trick is that you're converting what you see in three dimensions to a two dimensional image, and your use of lines and shapes can help add depth and dimension, impacting what your viewers see and feel.

» **Mandalay, Robert Holmes**

Working with lines is a key part of composition. Bob Holmes talked about using diagonal lines to add interest and vitality. But there are lots of other lines. Type into Google: "Getty understanding formal analysis" and you'll see a very informative article from the J. Paul Getty Museum giving examples of lines, forms, and shapes and what they convey to the viewer, along with other enlightening data about art.

» Bean Pond Road, Lyndonville, VT, Marc Silber

Another powerful use of lines is converging lines, such as this road going into the distance that I captured in Vermont. These lines show depth and lead the viewer's eyes into the image, something that Chris Burkard talked about.

Also google: "Mood lines," then click on images and you'll see a chart of 56 mood lines and the feelings or emotions they convey. Camille Seaman advised that you look at the shapes of the objects in the space that you photograph and "choreograph" them in your composition by changing your position in that space.

A fantastic exercise would be to go out and shoot examples of some of these key lines and shapes to learn the language of geometry.

ON POINT CRITIQUES

One of the key components of a photography school is frequent critiquing. When I attended the San Francisco Art Institute, students would meet with the instructors each week in one of the studios. Three of the walls were covered with white pushpin boards; those blank walls would stare back as you'd post your week's work. Then the instructor would go to each photographer's work and comment upon it along with the rest of the class.

This is not always easy and fun, nor is it always constructive. But in the worst case it would at least teach you that you don't have to listen to everyone's opinion of your work! In the best case, you would learn something from the feedback.

When I was first seriously learning photography in the 7th grade, I was critiqued by my dad's patient, "Father Vintner," a minister who was also a serious amateur photographer. When he offered to take some of my negatives, print them, and make comments on the back, of course I was delighted, if a bit apprehensive about

what would come back. They were returned to me as well printed 8 x 10s, each with a short typed critique on the back.

Comments were to the point, such as, "What would have happened if you'd taken a few more steps closer?" "Slightly out of focus or camera shake. Use a tripod, or faster shutter speed and hold steady," and of course the occasional "Superb, I only wish I had taken it!"

His precise notes were on point, allowing me to look at my skills and how I could improve. The other aspect was that they began a conversation. Up to that point, only I had viewed the photos, with no real feedback. Art needs to be released to the world as a vital and living form of communication, which then sparks conversation.

It's also important to learn to critique other's work. As Father Vintner did for me, tell them what you see, as their audience. But make it clear when you are stating a fact like, "It's a bit out of focus," or, "My eye is taken in two different directions" versus an opinion – which composition and framing often are.

A great way to critique is to get together with some friends or colleagues and start an "AYP Club." You can get together on a regular basis to critique each other using the book and videos as your guide. You can even create assignments to try out different points and different genres from the book.

Here is a simple and direct approach to critiquing:

1. Your intention should be to help other photographers advance. Be **specific** and **constructive**.

2. Lead with something positive, what you like about the image, and again be specific. Even if there are things you see that could be improved, lead with what you like or admire in it. It could be, "I love the strong colors you captured."

3. If you see something that could have been improved, note it, but only one point. (If there are several points, just find the one that you see as the biggest departure point.) Again, be very specific. This could be, "It would be more effective for me if you had stepped closer to your subject so that I'm drawn in to him/her."

And remember, when you put your images on Instagram or Facebook, hashtag them #AYPClub, so I and others reading this book, can give you feedback.

CRASH COURSE/SUMMARY

1. Continue to advance your photography on an upward spiral.

2. Do what you cannot do and learn from it.

3. Be obsessed with learning your craft.

4. Compile your reference library, keep it handy, and access it often.

5. Go analog and keep notebooks and a reference binder.

6. Use your online resources, but be choosy and stick to reliable ones.

7. Learn from other photographers and ask about what was successful for them.

8. The best way to learn is to teach.

9. Advance your composition by learning the language of geometry, including lines and mood lines.

10. Get and give on point critiques and use hashtag #AYPClub.

EPILOGUE

I'm very happy that you've chosen AYP to help you advance to your next level and beyond. Your journey upward is assured if you continue to apply what you have learned here. I'm hoping that AYP will be a constant companion for you in your camera bag and in your studio when processing.

On that note: be sure to set yourself up a "studio" no matter how small to begin with. This should be your designated space where you keep your equipment, your reference books, your digital darkroom, your prints, etc. You might remember that I set up my first darkroom in the family laundry room/shop. I will tell you that even though the room did triple duty, my space was sacred; no one messed with it by using it to store unmatched socks! Create your studio and make it your creative home base!

As I'm always learning I will continue to post new discoveries on the AYPClub.com pages that I believe will help you. I'd love you to help in that process too. Feel free to contribute what you have learned and what you believe will help other photographers advance. (Also use #AYPClub on your social media.)

Now, before we sign off, let's circle back to our subtext: "A handbook for creating photos that you'll love."

As I write these words again, I hear the Beatles singing: "And, in the end, the love you take, is equal to the love you make."

When you have the balanced give-and-take of life, you experience the satisfaction that Paul McCartney is conveying with

those words. You have learned a great deal about photography in order to create photos that you love, but it's actually best to look beyond that and create what others will love. I wish you the very best in doing just that.

We've come a long way through the cycle of photography, and by continuing to learn, shoot, and share, you'll keep advancing. I want you to know that you can always reach out to me for feedback or help. I look forward to being in touch.

Until then, remember to get out and capture your own images of life!

Marc Silber
Carmel, California

» **Marc Silber stepping through the door, Robert Holmes**

GLOSSARY

This glossary contains the key photographic and related terms as they are used in the book (there are often many other definitions for these words that are not covered here). Please use this glossary in conjunction with the book as there are illustrations accompanying many of the terms. Words that are clearly defined in the text such as in the processing chapter for Lightroom are not repeated here; please refer to the text itself. As needed, consult a photographic dictionary: I recommend Tom Ang's *Dictionary of Photography and Digital Imaging*. For English language words, consult a good dictionary. I recommend the *Concise Oxford English Dictionary*.

AF: auto focus, a setting on your camera where the lens will adjust focus semi-automatically, based on settings in the camera.

air bulb: a rubber ball with a plastic tube to blow dust away by squeezing it to produce an airflow.

analog: referred to here as not digital or not using a computer, such as keeping a paper notebook.

aperture: an opening or hole in a lens. It comes from the Latin word "to open". Adjusting the aperture allows more or less light

into the camera, thus changing the exposure. But it also changes the depth of field (refer to that definition and illustration on page 65).

artist statement: a few paragraphs about your style, your approach to and love of photography, and your influences.

AYPClub: a resource web page for items mentioned in the book and recommendations. It is also a group of photographers who get together on a regular basis to critique each other using this book, AYP videos and other resources.

AYPClub#: a hashtag you can add to your images in social media so that they can be seen by the AYP community.

bag: short for equipment bag, where you carry your camera and other gear.

bio: short for biography. The bio should give your story briefly; you can say where you studied photography, or that you were self-taught, etc.

brand: "A brand is a singular idea or concept that you own inside the mind of a prospect." – Al Reiss.

camera: a device for recording images, on film or digitally. In its simplest form it simply has a hole or a lens and a box where the film is exposed to light. More complex cameras have removable lenses and many controls. The word camera comes from the Greek word meaning an object with an arched cover.

capture: to create a digital image, a photograph. When your visualization is coupled with your ability to use your camera, you will then be able to capture the image that you want. Capture includes using your tools of composition (see composition and visualization).

Chief Marketing Officer: the head person in charge of marketing, which in this case it means promoting and selling your work.

Caravaggio: an Italian painter (c. 1571–1610) He was known for his dramatic use of dark tones and shadows with resulting strong contrast.

clipping: an overexposed or underexposed part of an image. It's as though you cut or clipped off the highlights or shadows so no detail will be recorded in those areas.

collection: a group of images in Lightroom that you can create. Also a physical or mental collection of images that you may have seen from others in museums, in books, etc.

composition: "Composition is simply the arrangement of your subject matter within the confines of your picture space." — William Palluth

contact sheet: called a "contact sheet" because you simply lay the negatives in contact with the printing paper and expose them with no enlargement. This results in tiny images, like thumbnails in digital photography that offer a preliminary view of your images. Also called a "proof sheet." (See example on page 121).

contrast: contrast determines the degree of difference between the brightest and darkest parts of the image. Increasing contrast makes the image more distinct in terms of showing the brightest and darkest parts of the image. Decreasing it brings these tones closer together as gray or middle tones, which can make the image look "muddy."

converging lines: lines that show depth and lead the viewer's eyes into the image, such as converging tracks in a road (see image on page 220).

critique: to give feedback on a photograph, usually by focusing on the positive aspects while suggesting a specific change or two that could improve it. It should never disparage the artist.

crop: to remove outer portions of an image, in order to remove distractions or change the framing (see framing).

cropped sensor: some cameras have a full sized senor which records the image as the same size as 35mm film. Other cameras have a smaller sensor which is thus called "cropped." Also see "sensor."

cropped sensor factor: the amount by which a sensor is cropped. See illustration on page 64.

cycle: a complete series, connected together, with an end result. Example a dishwasher goes through a cycle of prewashing, washing with soap, rinsing and finally drying, with the end result of clean dishes.

cycle of photography: all the parts of photography from first visualizing an image to the point of sharing it with others; fully covered in Chapter 1.

darkroom: a room where one can develop film and make prints. It is kept dark or nearly so to prevent unwanted exposing of the film or prints.

depth of field: how much is in focus or not. A "shallow" depth of field has a narrow area of focus (mainly the subject.) A wide depth of field increases what is in focus. It could also be called "depth of focus."

decisive moment: Photographer Henri Cartier-Bresson captured what he called the "Decisive Moment", where he photographed

his subject at exactly the moment that captured the true spirit of their action.

Develop module: one of the sections or modules of Lightroom where you process the image according to your visualization of it. This is fully covered in Chapter 5.

digital: refers to the use of electronic capture of an image as opposed to exposing film.

distillation: extracting what is most important.

DSLR: digital single lens reflex. This means that you view through a single lens that is also used to expose the image digitally. Reflex here means that the light is reflected by a mirror up to where you can view it.

environmental portraits: to capture a portrait of your subject in their environment, often showing their signature accouterments. Those in the photo may have a relaxed or even moody expression (rather than posed with a smile.)

equivalent: something that is considered to be equal to or have the same effect, value, or meaning as something else.

exposure: the amount of light that reaches the camera sensor. It has three variables: shutter speed, aperture and ISO, see chart on page 78).

exposure compensation: a way of adjusting your camera's exposure, such as to eliminate clipping (see clipping).

focal length: the distance (usually measured in millimeters or "mm") from the principal rear point of lens to the focal point where the image is in focus at the sensor.
(See illustration on page 70).

focus: how sharp or blurred something in the camera or image is. This is manually controlled by a focus ring or by auto focus, or AF (see AF.) Selecting focus allows a photographer to emphasize or deemphasize parts of the image.

framing: putting an edge or border on your photograph by finding and including a natural frame, such as a window, door or tree branch. It also means to fit what is happening in the scene being photographed into the frame of your camera so that you have "...a precise organization of forms which give that event its proper expression." — Henri Cartier-Bresson.

f-stop: the size of the opening a lens. They are expressed as fractions so the larger the denominator (bottom number) in the fraction, the narrower the opening of the lens (see illustration on 65).

genre: a category of art or photography, having a commonality to them. Examples of genres are: sports, travel, environmental portraits, etc.

geometry, solid: geometry deals with points, lines, shapes and space. Solid geometry deals with three-dimensional objects and lines that we see around us such as circles, spirals, cubes, etc.

JPEG: short for Joint Photographic Experts Group, a digital image format that compresses images, which can cause loss of control and loss of details in your image (see RAW).

full frame sensor: in a DSLR, the sensor is the same size as a piece of 35mm film.

golden hours: generally half an hour before and after sunrise where the sun is at a low angle which make the light warm and softer (see soft and warm).

highlights: the brightest parts of an image.

highlight alert: a blinking warning on image playback where clipping has occurred. Also called "Highlights." (see clipping.)

histogram: shows what your image looks like on a graph in terms of exposure. The left side shows the darkest parts of the image, the right side shows the brightest, in between are mid-tones. The word histogram is derived from the Greek histo meaning mast (or vertical lines) and gram denoting something recorded as a graph. So in our case it is an indicator, a graph showing the range of light of your image.

horizontal: parallel to the horizon. In the case of processing it means to control the part of the image that is parallel to the horizon.

ISO (International Organization for Standardization): a standard number that indicates how sensitive your sensor and camera are to light. The lower the number, the less sensitive.

lag: the time between one event and another.

lab: a facility that develops film and makes prints from them or from digital files.

landscape framing: photographing with your camera so that its long edge is parallel to the horizon. This results in an image with the long edge on the bottom, often (but not always) suitable for capturing a landscape photograph, such as scenery.

layers: in composition these are the various "slices" or sections of an image or scene, such as the background, foreground and middle ground.

lens: a camera lens is made up of a group of individual lenses that work together to gather and focus light rays, so that you can control the image that you want to record. The word lens comes from Latin "lentil" because its shape was similar to one (see illustration page 62.

Library: a module in Lightroom that stores and organizes digital images.

light meter: a device that measures the amount of light on a given scene or subject. It tells you possible exposure settings based on how you want to capture the image. Digital cameras have built-in in light meters. (See photograph on page 210.

Lightroom: Adobe brand digital processing software, allowing you to store, develop and share your images. Abbreviated Lr. The controls for Lr are fully covered in Chapter 5.

loupe: a view in Lightroom that magnifies the thumbnail (small image) by opening the full image. A loupe is a magnifying glass used by jewelers, hence it magnifies the thumbnail view.

memory card: a small removable card that records images that your camera sends digital images to, often simply referred to as a "card".

MF: manual focus, controlled by turning the focus ring on your lens.

Michelangelo: Italian multi talented artist (1475-1564). He had an extraordinary blend of spiritual insight, realism, intensity and genius that made him be considered one of the greatest artists of all time.

mm: millimeter or 1/1000th of a meter. There are 25.4 mm to an inch.

module: one of the main units of Lightroom (see Lightroom).

mood lines: lines that convey feelings or moods in composition, for example two close parallel lines can show opposition.

muted: colors that are less distinct and bright, for example by lowering contrast (see definition of contrast).

negative: an exposed image on film that has become visible and fixed through a chemical process called "development."

noise: random disturbances or variations in the image, generally undesirable. Increasing ISO can increase noise (see illustration 78).

photography: the art and practice of visualizing, capturing and processing photographs. It comes from two Greek words: "phos," meaning "light," plus "graphein," "to write." Put them together and you have the art of writing with light! In full it has five stages as fully covered in Chapter 1.

photograph: (noun) I use "capture", "image" and "shot" interchangeably to mean a photograph. (verb) I use "shoot" or "capture" as the verb; the action of photographing

photographer: one who uses the tools of photography creatively to create images that can convey meaning and emotion. A photographer does this with purpose and intent as opposed to someone just taking snapshots.

points of thirds: the idea that John Thomas Smith put forth in about 1797 that you could break an image into grid lines of thirds as an aid to composition. He said that by placing elements on

these lines you could create a "harmonizing image." (see page 94 for illustration.) However it is not a "rule of thirds" as it is often referred to; rather it is a guide one can use or not as an aid to composition.

portfolio: a collection of photographs.

portrait framing: positioning your camera so that the long edge is vertical, not parallel to the horizon. This can be used (but not always) to capture a person's portrait.

prime lens: a fixed focal length lens as opposed to a zoom lens (see zoom lens).

processing: in digital photography, using software to control how you want the image to look, fully covered in Chapter 5.

RAW: an image file where your camera captures the information and sends it to your card unprocessed. There are settings for different sizes of RAW files, including sRaw for small RAW files.

reflector: a reflective surface that can be used to direct light onto your subject. Many items can be so used: newspaper, a white shirt, or a sheet of aluminum insulation, as well as commercially made reflectors.

Rembrandt: A very influential Dutch artist (1606–1669). He is known for his portrait lighting style where one side of a face is lit directly and the other side is shadowed, causing an inverted triangle shadow from the nose, both of which can be flattering.

saturation: the overall amount of color in your image.

scene: a specific area you are photographing or photographing

in. There could be many scenes in the course of one assignment, for example shooting a sports event could be on the field, in a the locker room, later celebrating, etc.

selects: these are images that you pick or select as preferred over others in a group, often moved to a new collection (see collection.)

sensor: a sensitive surface that captures light, behind where the lens attaches, called the "sensor." Together with other digital components, it detects and translates light into digital information that is recorded on your card. (See "memory card".)

set: the area where you are photographing along with its furniture, and other objects. This could be an office a living room, classroom, etc. These items are often moved around or "set" in place.

sharing: getting your work out in the world, such as through social media, getting prints made, and showing your work.

shot: see photograph

shot list: a list of images that you intend to capture at a wedding, event, or on your travels, etc.

shoot plan: your plan for how you are going to do your shoot. This could be a simple drawing of how you will arrange the scene or "set". It could also be your plan for the schedule of a shoot and how you are going to approach it to get all the images on your shot list. (see scene, set, shot list.)

Silver Efex Pro 2: this is free software provided by Google that turns color images into black and whites, described in Chapter 5.

shutter: a device that opens and closes to let light in to the

camera, like a shutter on a window. Because you can vary its speed you can let more or less light in to control the exposure.

shutter speed: the shutter opens and closes at variable speeds to control the amount of light for exposure. Faster shutter speeds will stop motion, while slower speeds can exaggerate motion.

soft (light): light that tends to cast gradual shadows around the subject and so "softens" the edges around them. An example is light at sunset when the sun is at a low angle, as opposed to midday light with "harsh" edges. (see golden hours)

stages of photography: each of the five distinct parts of the cycle of photography fully described in Chapter 1.

still life: a genre of photography using inanimate objects, often arranged together. (see example on page 200).

subject: the person or main point of interest you are photographing.

telephoto lens: a lens with a longer than normal focal length which causes it to have a narrower field of view and magnifies the image, also called a "long" lens. (See focal length and illustration on page 70).

tint: a shade of color. In this case it is an unnatural or unwanted additive or cast to the natural color (such as a blue or yellow tint.) It is also a slider in digital processing to properly set white balance (see below).

tone: how light or dark your image is, including shadows, highlights, and how much contrast it has. Tone comes from a Greek word meaning "stretched," which means to have the

values aesthetically placed the way you want it to look.

value: the relative degree of lightness or darkness of parts of an image. (See tone and zone system.)

vampire: people who try to rob you of your life and what you have created.

venue: a place where art and photography are exhibited.

Vermeer lighting: lighting that is similar to that used by Johannes Vermeer, generally using a window as the single light source (see page 108 for an example).

vertical: perpendicular to a horizontal line or edge.

viewpoint: the point you photograph from and the view and want your audience to take. For example, looking down on your subject, instead of straight on.

visualization: the process of forming a mental image of what you are going to photograph, and how you intend it to look as an end result of all the stages of photography.

warm (light): light that is more red, orange or yellow, such as during the "golden hours" whereas mid-day light is blue (see definition of golden hours).

white balance: settings you adjust so that the colors your camera sees are what you see, without any unwanted tints . Adjusting white balance will make whites appear as you see them when you capture the image and so are properly "balanced." Abbreviated WB. (see tint).

wide angle lens: a lens that takes in a wider than normal view of

an area because it has a shorter focal length (see focal length.)

zone system: this system divides luminance (relative brightness) of a scene into 10 zones: zone I is pure black, zone V is middle grey, and X is pure white. You can easily correlate this to the histogram to see that it's another way of evaluating light. A change of one zone corresponds to one f-stop.

zoom lens: a lens with a range of variable focal lengths, as opposed to a prime lens (see definition of prime lens.)

APPENDIX 1 – IMPORTING INTO LIGHTROOM

Let's start from the beginning and walk through your work flow to move from what's in your camera to storing it in your computer.

Importing your existing images:
I'm going to assume you already have many files of existing images in your computer, so let's start here. But if not, just go to the next section...

1. Before we even start to import, let's make sure some basic housekeeping is done. You can refine this as you move along, so it doesn't need to be super fine-tuned.

2. Create an overall folder for your Lr images called "Lightroom Photos". Put all of your folders with your photos inside them in one place, usually in **Pictures**, or better yet in an external drive – which you'll need as your library grows!

3. Look over the names of your folders for your photos and ensure they make sense. A good rule of thumb is to name them so someone else could easily find them, that way you should be able to as well!

4. If you have several trips to Mexico, then name them with the year, e.g., "Mexico 2008" or "Mexico 2015," etc.

5. Now start Lr. As you have nothing in it, you should see the import dialog come up. If for some reason it doesn't,

just go to File > Import Photos and Video, and the dialog will come up.

6. On the left side pane you'll see "Source." Click on your **Pictures** folder (or your external drive if you have one) and click again to your **Lightroom Photos** folder.

7. Now look at the top of the dialog, you'll see "Add" – click on that (since you're not moving or copying).

8. Now look at the lower right of the dialog and hit "Import" and let it run!

9. Once this has completed (you'll see progress in the upper left bar), you will now see the Library module. In the upper left pane, you'll see "Catalog"; below that, "Folders". Click on where you have **Lightroom Photos,** and you'll see the folders you just moved there!

IMPORTING FROM A MEMORY CARD

1. Start by making your **Lightroom Photos** folder as in step # 2 above.

2. Make sure your camera is turned off, and carefully remove the memory card. Treat it with respect, don't drop it or put it down on a dusty desk, etc.

3. Start Lr.

4. Insert it into your computer's card reader, or use a separate card reader.

5. As soon as you insert your card, the import dialog will come up. If for some reason it doesn't, just go to File > Import Photos and Video, and the dialog will come up.

6. You will then see on the left pane "Source" with your card listed at the top.

7. At the top you'll have some choices. I suggest you use "Copy as DNG". DNG means "Digital Negative" and was created by Adobe as a universal format for RAW files, instead of each camera's version. There are several advantages to using DNG, including smaller file sizes. Now look at the right pane "Destination". Click on "Into Subfolder" and to the right of that give the folder a name (see #3 above about naming folders).

8. Now look below that and find your **Lightroom Photos** folder. If you put it in **Pictures** it will be under your home folder >Pictures> Lightroom Photos.

9. Once the above is all set, just click on Import on the bottom right and let the import run!

APPENDIX 2 – BASIC PHOTOGRAPHY SHOOT CHECKLIST

This should be modified and added to by each photographer to suit their needs.

- ☐ Research for shoot + notes

- ☐ Check weather and prepare accordingly

- ☐ What you intend to capture: (include full shot list if need)

 Equipment Bag:

- ☐ Camera

- ☐ Back up camera

- ☐ Lenses

- ☐ Charged batteries

- ☐ Backup batteries

- ☐ Strobe(s)

- ☐ Strobe Batteries

- ☐ SD or CompactFlash Cards (formatted)

- ☐ Lens cleaning kit

- ☐ Remote Control Shutter release

- ☐ Filters

- ☐ Compressed air or air bulb

☐ Business cards

☐ Tripod + tripod plate

☐ Misc: screwdriver, cables, etc.

☐ Mobile drive to back up (plus computer and card reader)

☐ Reflector(s)

☐ Umbrella

☐ Water + snacks

☐ Field guide for camera

☐ AYP Book!

☐ **Double-check all equipment before leaving studio!**

INDEX

SHUTTERSTOCK CREDITS

Page 13 grass-lifeisgood/shutterstock.com

Page 31 Pavel L Photo and Video/shutterstock.com

Page 54 rdonar/shutterstock.com

Page 62 Alex Mit/shutterstock.com

Page 63 nanmulti/shutterstock.com

Page 65 BeeBright/shutterstock.com

Page 70 Alhovik/shutterstock.com

Page 73 cbproject/shutterstock.com

Page 78 BeeBright/shutterstock.com

Page 166 Callahan/shutterstock.com

Page 176 Maksym Darakchi/shutterstock.com

Page 207 Ollyy/shutterstock.com

ABOUT THE AUTHOR

Marc Silber is an award-winning professional video producer, photographer, and photography educator who has been successfully working in the field for decades. Marc combines his passion for the visual art of photography with his love of life.

He started out learning darkroom skills and the basics of photography at the legendary Peninsula School in Menlo Park, CA, in the '60s, and moved on to hone his skills to professional standards at the famed San Francisco Art Institute, one of the oldest and most prestigious schools of higher education in art and photography in the United States.

Marc has been an educator since then as well; he began his teaching career at the age of 19 at the National Outdoor Leadership School, teaching mountaineering.

When teaching a life-or-death subject such as mountaineering, one learns how to make sure the students understand the material; when Marc moved into teaching photography in workshops all over the country, he became renowned as an engaging and helpful speaker and coach, as his greatest joy comes from helping others.

More recently, Marc has embraced the digital age with a highly popular YouTube show called "Advancing Your Photography," which has won several Telly Awards and other recognition for his work there.

This book is a distillation of all the pro tips and wisdom in the YouTube series, in a format you can take with you and refer to constantly when you are out taking your photographs.